DIRECTOR'S CHOICE
BRIGHTON & HOVE MUSEUMS

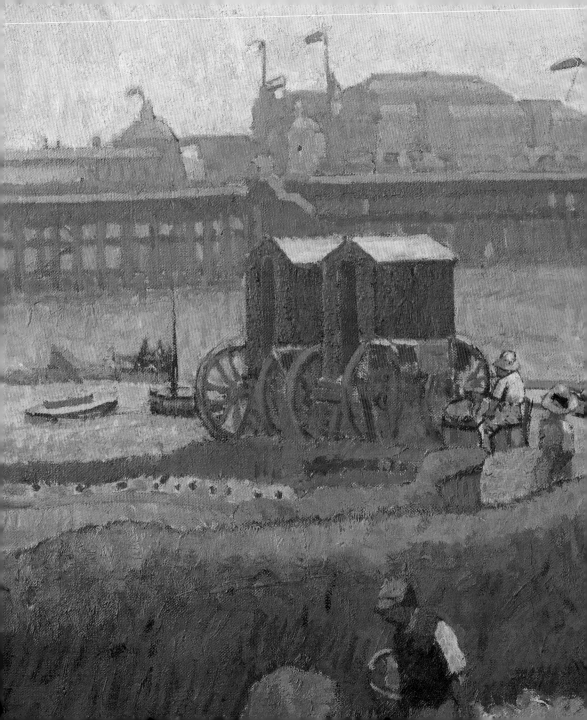

DIRECTOR'S CHOICE

BRIGHTON & HOVE MUSEUMS

Hedley Swain

SCALA

INTRODUCTION

BRIGHTON IS A UNIQUE PLACE, a small fishing settlement that in the late eighteenth century grew rapidly to become a highly fashionable resort and spa town. George, Prince of Wales, built a unique summer palace that became a symbol of decadence, revelry and flamboyant design. Brighton and Hove remains an important coastal resort and creative city, an important centre for celebration, freethinking and the very best in culture. All the elements that make Brighton and Hove special are reflected in the many facets of our museum service and we in turn contribute to the vibe that makes the city so distinctive.

The Royal Pavilion, George IV's iconic seaside palace – with its picturesque landscaped garden, Mughal-style exterior by John Nash, and Chinoiserie-dominated interior – sits at the very centre of Brighton, forming part of the Royal Pavilion Estate which also includes the internation -ally renowned arts venues Brighton Dome and the Corn Exchange. The Royal Pavilion came into the ownership of the Brighton Corporation in 1850 when it was purchased as an empty shell from Queen Victoria, who had relocated her summer home to Osborne House on the Isle of Wight. Since then, it has been painstakingly renovated to reflect its glory days with many objects originally acquired for the Royal Pavilion and now on loan from Her Majesty The Queen.

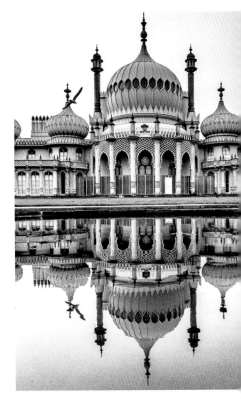

The Royal Pavilion & Garden from the East Lawn

Brighton Museum & Art Gallery was originally housed in the Royal Pavilion but in 1873 moved to a new purpose-built site in the Royal Pavilion grounds. It houses renowned collections of local history, archaeology, world art, decorative and fine art that reflect Britain's global history and influences. The Booth Museum of Natural History, located in a quiet suburb, was created by Edward Thomas Booth in 1874 and came into the ownership of the Brighton Corporation in 1891. Booth set out to shoot,

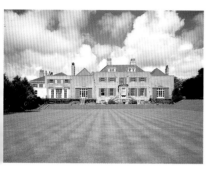

Preston Manor & Gardens

Brighton Museum & Art Gallery

stuff and display an example of every native bird species in the United Kingdom, and in so doing devised the idea of life-like diorama settings for natural history taxidermy specimens – a technique that became the norm for natural history museums across the western world.

Preston Manor & Gardens, on the main road north out of Brighton, is a charming historical house surrounded by gardens, bequeathed with its collections to Brighton Corporation by the Stanford family in 1932. Its interior has been preserved as an Edwardian house and the grounds include a much-loved walled garden. Finally, Hove Museum of Creativity, which was also a private house until given to Hove Borough Council. It has become a centre for craft and creativity and has an important collection of early cinematography, reflecting Brighton and Hove's special place in the origins of the film industry.

Our holdings are eclectic, but of the highest quality: three collections are designated as being of national and international importance (decorative arts, world art and natural history) and other collections of major significance including regional archaeology, costume and fashion. To stay relevant, museums must play an active role in their communities and reflect those communities in their collecting and curatorial decisions. We continue to engage with Brighton and Hove's more recent and contemporary history as a resort town close to London, popular for day trips, and as a city associated with freedom of expression and many sub-cultures. For example, we have pioneered the inclusion of LGBTQ+ collecting, curation and displays in our work. From Edwardian walled gardens to Victorian stuffed birds, from Bronze Age amber cups to mod scooters, from same-sex wedding costumes to pioneering film cameras, we tell many stories that continue to chart a changing world and offer to residents and visitors a service that is far more than the sum of its parts.

EDWARD THOMAS BOOTH, PRATT AND SONS (BRIGHTON)

Gannet and golden eagle dioramas, 1878 and 1874

Multimedia and taxidermy, each 186 × 280 cm

Bequeathed by Edward Thomas Booth to the Booth Museum of Natural History in 1890.

BCD000001 and BCD000153

THE BOOTH MUSEUM OF NATURAL HISTORY, originally known as the Booth Museum of British Birds, was the private museum of Edward Thomas Booth. As an only child, Booth inherited his family fortune, so was able to devote his life to his passion for shooting and collecting British birds. He built the museum in the grounds of his mansion and set himself the aim of making the country's only dedicated museum to all the native and migrant birds in Britain. These species would be displayed in recreations of their observed environment and behaviour, and at each life stage.

To achieve this Booth sketched or painted the birds as he observed them in the field, before hunting them. These reference sketches were then provided to the taxidermists he employed to create dioramas which accurately depicted the natural environment. These dioramas are the first known examples of natural history specimens being displayed in recreations of their natural environment.

The grandest of these dioramas are eight huge displays at the front and the back of the museum. These include the gannet colony and the life stages of golden eagles pictured here. The natural dioramas inspired the Natural History Museum in London and the American Museum of Natural History, who both created dioramas at a much grander scale. However, the Booth Museum has been recognised by the Smithsonian in Washington, DC as the 'home of the diorama' for the pioneering work done by Booth and his taxidermists.

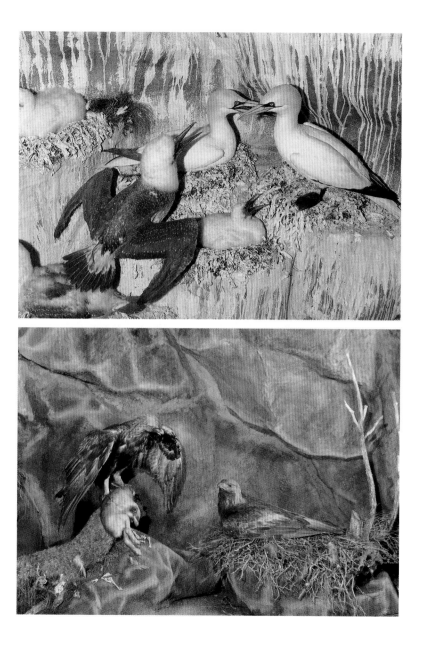

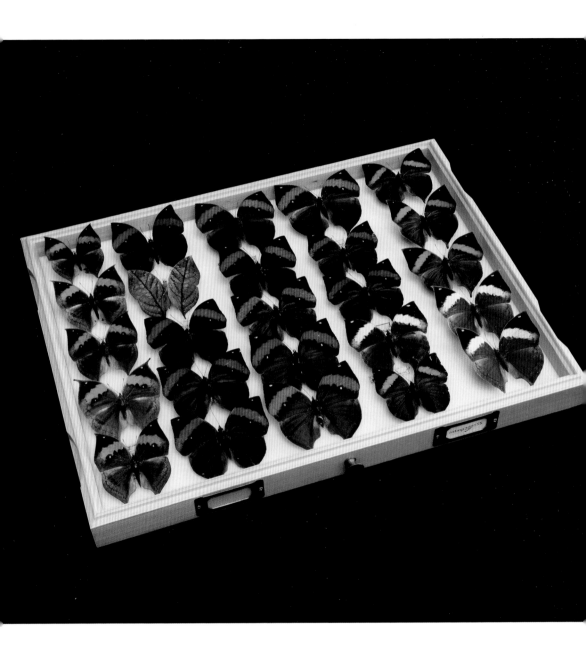

ARTHUR HALL, 1873–1952

South and Central American butterflies, 1901–39

Pinned insects

50,000+ specimens, multiple accession numbers

IN THE YEARS SINCE THE BOOTH MUSEUM was bequeathed to the Brighton Corporation, it has evolved from being a museum of British birds, to a natural history museum preserving the entire diversity of life. Osteological, botanical and geological collections have all been added since the 1960s. However, the first change to the original museum was the transfer of the British Museum's secondary collection of butterflies in the 1930s. Since then, the entomology section has more than doubled as other collectors have donated their specimens.

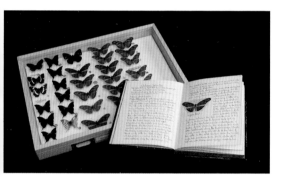

The most scientifically important of these later entomology donations is that of Arthur Hall. His pinned-butterfly specimens occupy more than 30 cabinets. Though many of these were obtained by exchanging specimens with his contemporaries, the South and Central American specimens are from his own expeditions. From 1901 until the outbreak of war in 1939, Hall made 13 trips to the Americas for his entomological work. On these trips Hall collected and described more than six hundred and fifty species unknown to science. These are preserved as type specimens, and though some are housed at the Natural History Museum in London, most remain in the Hall collection at the Booth Museum. The collection also holds possible future types identified using modern techniques – the most recent of these was studied in 2015. Hall's life's work was a 54-volume monograph on the butterflies of South and Central America, and although he died before it was published, this monograph remains in the museum along with his collection and has been made digitally available to researchers.

SIR ALEXANDER CRICHTON, MD, 1763–1856

St Petersburg book (7 volumes), 1805–15

Paper, plant fibres and leather, each volume 45 × 30 cm

Donated by Sir Alexander Crichton in 1920 to the Booth Museum of Natural History

BP305366 / BP305557

THE BOTANY SECTION OF THE BOOTH MUSEUM houses a large amount of material collected in and around Sussex and this makes up the majority of the herbarium's research collections. However, there are also some interesting historic collections, such as the Arctic plants collected by the assistant surgeon Alexander Crichton while on board HMS *Fury* during the first voyage to find the Northwest Passage (1821–23).

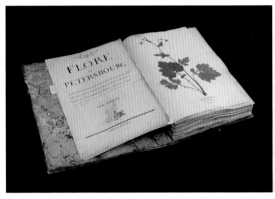

Our oldest botany specimens consist of a seven-volume herbarium of pressed plant specimens. This is the personal collection of Sir Alexander Crichton and is probably one of the first herbariums compiled in Russia. Crichton was a doctor who was one of the first to medically identify ADHD in his three-volume text, albeit rather archaically. Following this work, he accepted the role of chief physician to Tsar Alexander I and the Dowager Empress Maria. He remained in their service for almost 20 years, becoming head of civil medicine in Russia, and receiving the Knight Grand Cross of the Orders of St Anne and St Vladimir for work fighting pandemics in Russia's south-eastern states. He was later knighted by King George IV on his return to England. A member of the Linnaean Society of London, he spent much of his free time collecting and studying the natural world and built up both his herbarium and a geological collection on his travels around Russia. Both were donated to Brighton Museum by his grandson in 1920.

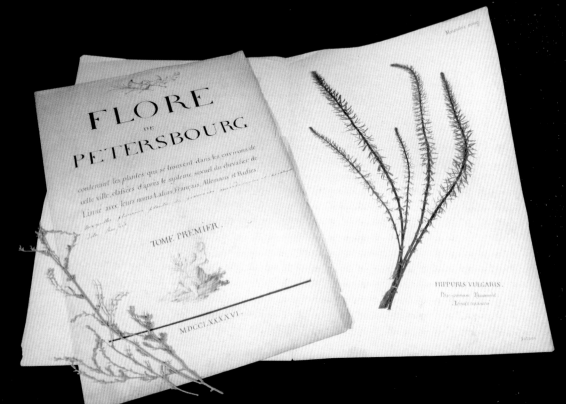

FLORE
DE
PETERSBOURG

contenant les plantes qui se trouvent dans les environs de
cette ville, classées d'après le système sexuel du chevalier de
Linné, avec leurs noms Latins, Français, Allemans et Russes.

TOME PREMIER.

MDCCLXXXXVI.

HIPPURIS VULGARIS.

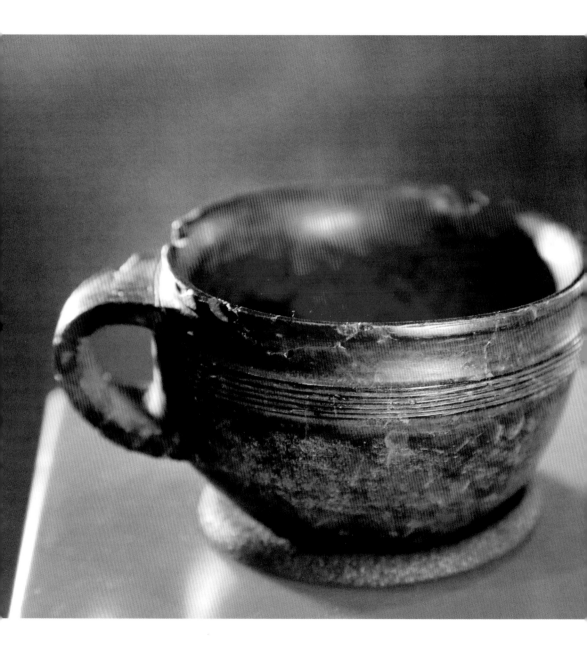

Hove Amber cup, early Bronze Age, *c.*1750 BCE
Discovered 1856 in Hove, Sussex

Amber; 6.35 cm height × 8.89 cm diameter
Presented to the Museum of the Brighton Royal Literary and Scientific Institution,
later Brighton Museum, by Baron Goldsmid via Barclay Phillips in 1857
HA2306088

BRIGHTON & HOVE MUSEUMS holds important archaeological coll-
ections for the Sussex region. This cup, an exceptional treasure of
British archaeology, was discovered in Hove Barrow, a Bronze Age
burial mound. Hove Barrow was a landmark on the coastal plain
between Brighton and Shoreham until it was levelled for housing in
1856, with its earth used to create public gardens nearby.

The home of local teacher and historian Barclay Phillips over-
looked the mound. He rushed down to the site as workmen uncovered
an oak coffin carved from a single tree trunk. Found within were
small bone fragments, a copper-alloy dagger, whetstone, a beautiful
volcanic stone axe head and the precious amber cup. Phillips re-
ported that once exposed to the air, the cup 'cracked slightly in every
part' but escaped the workmen's heavy tools relatively unscathed. The
coffin, however, 'immediately crumbled away' – only a single knot
was recovered. This fragment was radiocarbon dated by the British
Museum in 1971, placing it in the early Bronze Age.

The presence of this unique and valuable object suggests that
Hove Barrow was the grave of an important individual. The barrow
also offers evidence of trade and exchange of high value objects
across Europe, with the Sussex area a part of these networks. The
amber for the cup would have been sourced in the Baltic region.

Barclay Phillips placed the cup and the rest of the find in the care
of Hove Museum prior to its formal donation to the museum by Baron
Goldsmid, owner of the land on which the Barrow was sited. We
are fortunate to have such an object within our collection, the most
complete of only two amber cups found in Britain.

Black Rock Hoard, middle Bronze Age, *c.*1400–1250 BCE
Discovered in winter 1913–14 at Black Rock, Brighton

Bronze

Bequeathed to Brighton Museum by Dr C.T. Trechmann in 1965

R5644

LIKE MANY BRONZE AGE HOARDS, the Black Rock Hoard comprises weapons, including eight axe heads, and a blade with handle and pommel. It also features objects of adornment: two ovoid armlets and a coiled finger-ring, plus three rather curious twisted bands known as 'Sussex loops'.

Bronze Age hoards in the south of England are usually distrib -uted along the coast. The ritual burial of objects on the boundary of land and water was a common occurrence and the Black Rock Hoard, located near the coast, may be an example of this ritual. The handle and coiled finger ring may have been manufactured in Germany as much as two hundred years before the axes or loops, suggesting that the group of objects is a 'founder's hoard' – a collection of unused objects buried for possible later recovery. However, it may have been a more personal hoard collected over several generations and buried with ritual intent.

The Sussex loops are thought to have been used as bracelets. They are formed from a single bar of rounded or square-section copper alloy, their ends flattened and curled. Half of the 34 loops discovered to date have been found within a six-mile radius of Brighton, hence their name. This may suggest that they were the product of a local workshop or possibly even the work of one craftsman; no two loops are identical. The curvilinear form of the Sussex loops is the basis of the logo for Brighton and Hove Archaeological Society.

The hoard was lent to Brighton Museum in 1931 and studied by distinguished archaeologist Peggy Piggott, later Guido, in the late 1940s. It was bequeathed to the museum following the death of its owner, Dr C.T. Trechmann, in 1965.

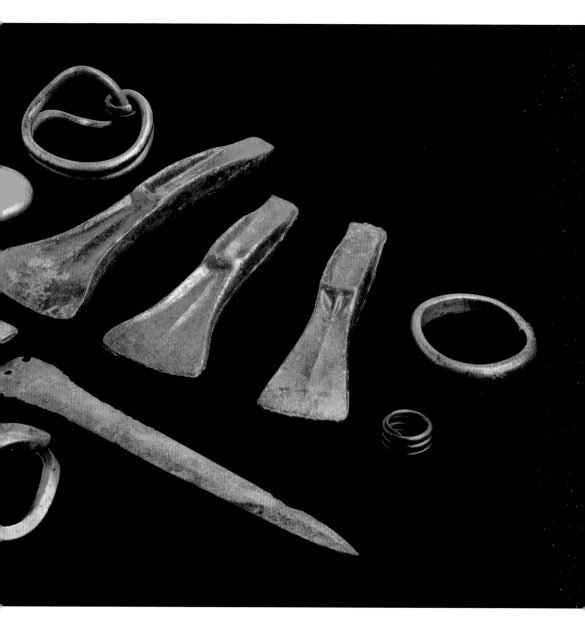

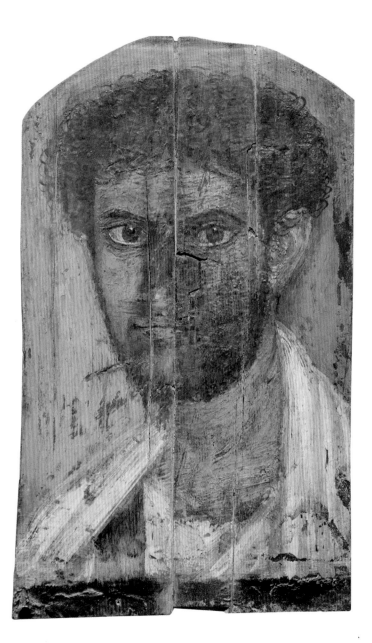

Fayum portrait of a man, 2nd century CE
Discovered during winter 1910–11 in Hawara, Egypt

Wax on lime wood, 38 × 21.5 cm

Donated to Brighton Museum in 1911, in lieu of subscription to The British School of Archaeology in Egypt

FA000412

BRIGHTON & HOVE MUSEUMS' collection of Ancient Egyptian and Sudanese artefacts is rated as one of the most important in the UK, thanks to its connection with Brighton-born Egyptologist Francis Llewellyn Griffith (1862–1934). His brother, Arthur Foster Griffith (1856–1933), was a member of the Brighton Museum Committee and a keen supporter of his sibling's work. The Griffith Institute at the Ashmolean Museum in Oxford, named after Francis, is one of the foremost Egyptological archives in the world.

This remarkable encaustic or coloured beeswax portrait was acquired from the British School of Archaeology in Egypt. The school was established by William Matthews Flinders Petrie (1853–1942), with whom Griffith first worked in 1884 with the Egypt Exploration Fund. Petrie's systematic excavation and reports provide an important source for the find contexts of such portraits.

The portrait was found fixed over the face of a mummified body in the Roman cemetery at Hawara in the Fayum Basin. These portraits are comparatively rare, found mainly in this area, and few of the mummies excavated by Petrie's team were embellished with portraits. It depicts a bearded man wearing a white tunic with a mauve stripe (or 'clavis') and shows how he wanted to be remembered after his death. He is young and healthy, and his clothes distinguish him as a member of the elite class of Romans who had settled in Egypt. The realistic portraiture gives a fascinating insight into what people looked like in second-century Egypt.

THE ROYAL PAVILION MUSIC ROOM CEILING

THE MUSIC ROOM AND THE BANQUETING ROOM are the largest rooms in the Royal Pavilion. Both were added by the architect John Nash (1752–1835) in 1817, shortly after King George IV (r. 1820–30) decided to give the exterior an Indian-style makeover. Both rooms are square in outline and 15 metres tall at their highest points. Nash placed a domed and tent-shaped roof atop each room, forming a bold contrast to the minarets and onion-shaped domes he added in 1818, thus creating the Pavilion's striking roofline.

Inside, the interior decorator Frederick Crace (initially with his father John Crace) and his 35 assistants created the sumptuous Chinoiserie interior of the Music Room. It is perhaps the most spectacular Chinoiserie room in Europe.

Dancing and music were important in Georgian culture, both in public social life and at court. Here, the king's band performed works by Mozart, Handel and Beethoven, as well as selections from Italian opera. Famous composers and musicians were invited to perform, including Gioachino Rossini (1792–1868), and the king was even known to sing, play the piano or cello himself.

It is a room that immediately draws you in and plays with your senses through sheer scale and intensity of colour. Decorative motifs such as dragons, bells and snakes appear in both two- and three-dimensional form. The shimmering deep red walls resemble a gigantic, lacquered box, and tall Asian vases and porcelain pagodas that once stood along the sides would have drawn your eyes upwards to the magnificent ceiling. There, more than 25,000 plaster scallop shells, covered in gold leaf and subtly diminishing in size towards the centre of the dome, seem to echo the movement of waltzing couples. Nine waterlily-shaped chandeliers, made by William Perry & Co in 1820, appear to float in mid-air. Tiny baubles of frosted glass on their edges resemble dew drops, and gilt dragons cling like butterflies to the outside of the large central chandelier.

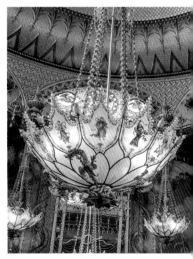

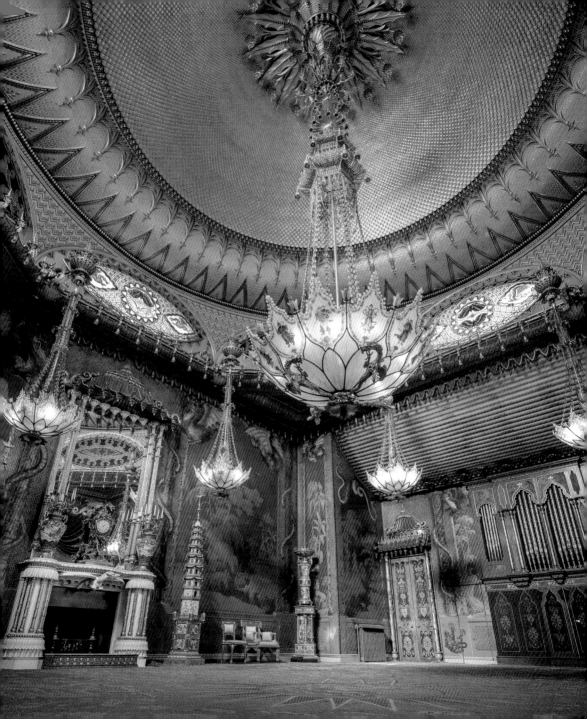

THE ROYAL PAVILION BANQUETING ROOM

ROBERT JONES

*Torchère, c.*1820

Spode (Stoke-on-Trent); Vulliamy and Son (London)

Ormolu, brass, porcelain, glass and wood, 291 × 50 × 50 cm

Donated in 1920

DA340553

THE BANQUETING ROOM, COMPLETED IN 1820, is the second great set-piece interior of the Royal Pavilion. It contains perhaps the most magnificent chandelier ever made. Thirty feet high and weighing 1 ton, this amazing object was designed by 'the chief decorative artist of the palace', Robert Jones, and made by Perry & Company. The dragon was supplied by the royal cabinetmakers, Bailey and Sanders.

From a mirrored star, a cut-glass fountain bears six lively dragons breathing light through lotus-shaped shades. The chandelier was originally lit by oil, a considerably vertiginous task for the lamp lighter. The light was said to resemble 'an artificial day'. In the 1860s the chandelier was converted to gas and in the 1880s to electricity. It has been removed three times: first, by William IV after Queen Adelaide had a dream that it had fallen on her husband. Reinstated in 1843, the chandelier was removed again in 1847, and finally returned by Queen Victoria in 1862.

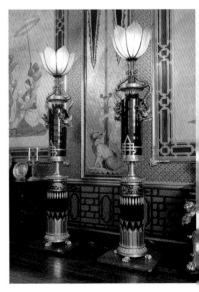

There are eight lamps or torchères, also designed by Robert Jones. The glass shades rise above deep blue cylinders of Spode 'stone China', thrown by a potter in four parts. The smooth blue surface was achieved by firing coloured transfer-printed sheets to the surface which was then glazed with cobalt blue. The glass shades, in the form of lotus plants, were made by Perry & Company and the gilt-bronze mounts supplied by B.L. Vulliamy. The ceramic cylinder is supported by a similar-shaped drum of painted wood. Lit by colza oil (rapeseed oil), the lamps are an example of the Pavilion court style at its confident best.

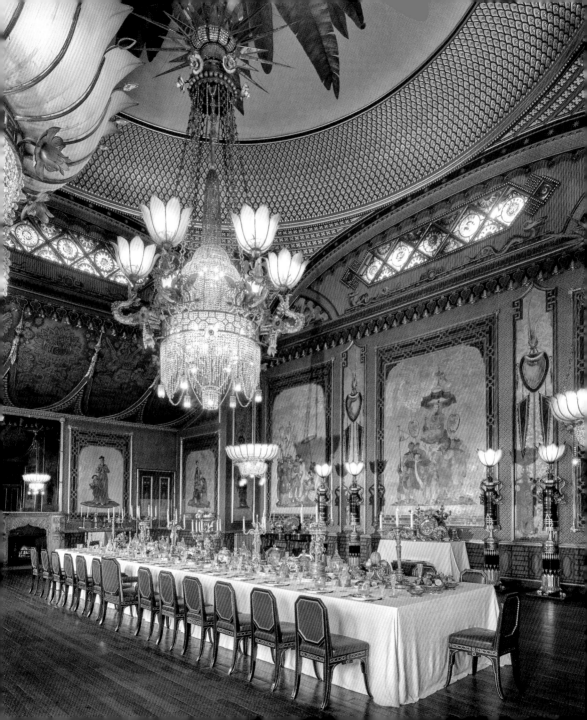

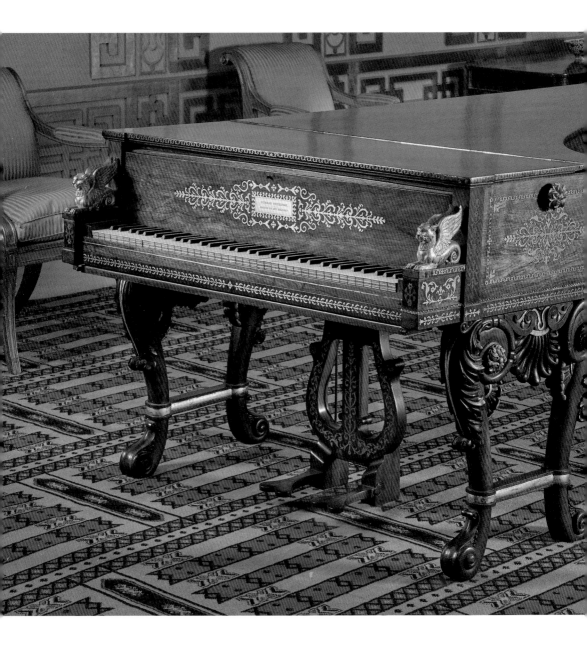

THOMAS TOMKISON, *c.*1764–1853

*Grand piano, c.*1821

Wood, brass, 245 × 118 × 295 cm

Purchased by the Royal Pavilion & Museums, Brighton & Hove with assistance from the Art Fund, Arts Council England / V&A Purchase Fund, The Leche Trust and the Royal Pavilion Foundation, 2017

R6036

FOLLOWING QUEEN VICTORIA'S LAST VISIT to the Royal Pavilion in 1845, the building was stripped of its contents in 1847–48, with the Brighton Corporation purchasing an empty shell in 1850. Quite soon, a process of renovation and restoration began and Queen Victoria returned fixtures not required at other palaces. In 2017 the Royal Pavilion acquired at auction a magnificent 'Grand Piano Forte' made for George IV in *c.*1821 by Thomas Tomkison of Dean Street, London – 'Piano Forte Maker to HRH the Prince of Wales'. The instrument can be seen in the entrance hall of the Pavilion in John Nash's *Views of the Royal Pavilion* (1826). Pianos by Tomkison were much sought after and examples made by him were widely exported. The patronage of George, Prince of Wales, as well as that of the Prussian court secured Tomkison's reputation. Costing twice that of a top-quality English piano, of the 25 pianos known to survive by this maker, this is the most splendid. The case is extravagantly decorative with brass inlay and gilt-bronze and the ends of the keyboard have winged sea-griffins which derive from a plate in Thomas Hope's *Household Furniture and Interior Decoration* (1807). Appropriately enough, the griffin is associated with Apollo, leader of the muses of artistic inspiration.

***Clay figure of a standing
Chinese woman (detail),***
late 18th to early 19th century
Canton (modern-day
Guangzhou), China
Modelled clay painted and gilt, 96 × 29 × 23 cm
On loan from Her Majesty The Queen
RCIN 26088

After Augustus Charles
Pugin, 1762–1852

***The Long Gallery, from
John Nash's 'Views of the
Royal Pavilion at Brighton',***
1826
Hand-coloured aquatint, 35 × 46 cm
FA207725

The Long Gallery of the Royal Pavilion is lined with a dozen brightly coloured Chinese figures, some standing, some seated, between 60 and 100 cm tall. They are prime examples of Chinese export ware, made in workshops in the south of China, close to Canton (modern-day Guangzhou) and Hong Kong, where traders of the East India Companies would buy goods that they thought might appeal to westerners.

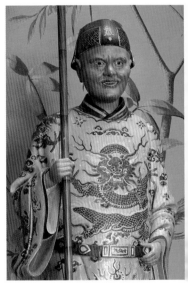

Sometimes described as 'Chinese Court Officials', these figures may also represent character types of the Qing dynasty. This was a period of intense cultural exchange and trade between China and the West, as well as foreign and domestic conflicts. Their most intriguing feature is that, when their heads are lightly touched, they nod gently. This may well have spooked inebriated Regency guests. The movement is possible because the head is separate from the hollow body. A weighted rod is attached to the bottom of head. This sits on a ledge, allowing for a rocking motion. These fragile objects are made from unfired clay painted in bright colours, and were often adorned with jewellery, silks, real hair and objects such as halberds made from bamboo cane.

The 'nodders' (also known as 'shakers') frequently come as pairs. Both male and female vesions exist, but without a reasonably good knowledge of Chinese costume and hairstyles it can be difficult to tell them apart. Heads and bodies frequently got mixed up when these figures reached the western market, and most were overpainted to fit in with the Pavilion interiors. George IV amassed one of the largest collections of 'nodders' anywhere, and they are first recorded in the Pavilion in 1803. Of the 12 now on display, eight are on loan from Her Majesty The Queen.

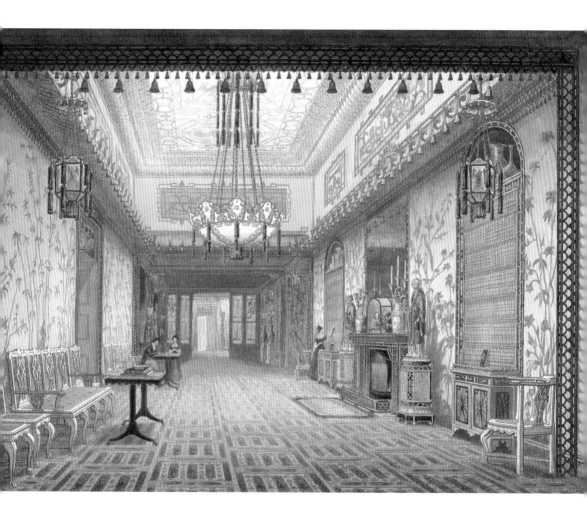

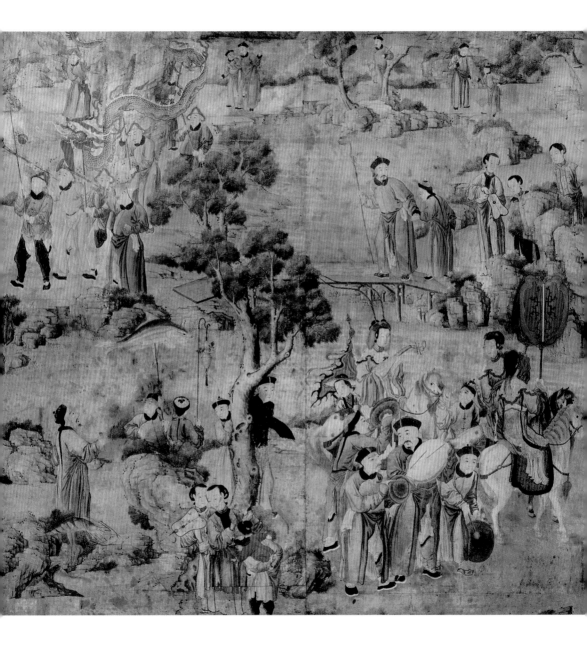

*Chinese wallpaper in the 'Adelaide Corridor', c.*1790
(hung in 1819)
Canton (modern-day Guangzhou), China

Paper

The Royal Pavilion

R6017

THIS FANTASTICAL EIGHTEENTH-CENTURY hand-painted wallpaper at the Royal Pavilion is part of the 'Adelaide Corridor' series. It was produced in Canton (Guangzhou) for export to Europe. It is remarkable for its longevity as much as its spectacular scenes, having survived in its original location for 200 years, one of few items in the Royal Pavilion that have remained undisturbed in this way.

The term 'Adelaide Corridor' was named after the adjacent Adelaide Tea Rooms, occupied by Queen Adelaide, wife of William IV, in the 1850s. However, this corridor and the rooms leading from it were part of the so-called 'New North Building', the last major portion of the Royal Pavilion to be built. It was completed in 1821. Senior members of the royal household had apartments there and some rooms were occupied by Lady Conyngham, mistress to George IV.

The left side of this scene depicts elements of a Lantern Festival. This is celebrated in China on the 15th day of the first month of the lunar calendar, and at the end of the Chinese New Year, with houses decorated with colourful lanterns during the festival. Other celebrations also include lion and dragon dances, parades and fireworks. Towards the top of this section a large dragon is being animated by the men supporting it on long poles. In the lower section are two lanterns with a marine theme.

The lower right depicts the story of Lady Wang Zhaojun, renowned as one of China's legendary ancient beauties. Lady Zhaojun is shown leaving her hometown on horseback and heading northward. She is extremely sad and begins to play sorrowful melodies on her lute. She is surrounded by actors and musicians, entertaining spectators around them.

DOMENICO MOGLIA, 1780–AFTER 1862 (AFTER SIR THOMAS LAWRENCE)

Mosaic portrait of George IV in Garter Robes, 1829

Oil and mosaic of coloured glass on stone and cement, 100.5 × 74 × 15 cm

Purchased by Brighton Museum from Dr Willington in 1888

DA330331

THIS LARGE MOSAIC PORTRAIT, copied from Thomas Lawrence's portrait *George IV in Garter Robes* (Vatican Museums), is made from around half a million pieces of opaque coloured glass. It was commissioned by Pope Pius VII from the renowned Vatican Mosaic Workshop as a gift for George IV. This was probably in recognition of Britain's role in helping end the Napoleonic wars (1803–15), during which the Pope had been imprisoned in France between 1809 and 1814. Pius would also have been thankful to the British for their diplomatic role and the finance provided to support the return of looted Italian artworks from Paris after the wars ended.

Master mosaicist Domenico Moglia used two distinct techniques to create the portrait. The more traditional method of *smalti tagliati* is evident in some areas of the red background drapes. These larger, more angular pieces were cut from slabs of coloured glass. The smaller, rounded pieces of coloured glass that make up the portrait are made from the refined *smalti filati* technique. This method involves heating coloured glass to a molten state before drawing it into narrow filaments using tweezers. When cut and embedded upright into a putty substrate, these short micro-mosaic rods (1–4 mm in section) enabled the artist to finely model facial features in the portrait that would otherwise be impossible with larger pieces.

The work was completed in 1829, six years after Pius's death. Unfortunately, George never saw the work before his death in 1830 and it passed into private ownership before eventually being bought by the Brighton Corporation in 1888 for display in the Royal Pavilion.

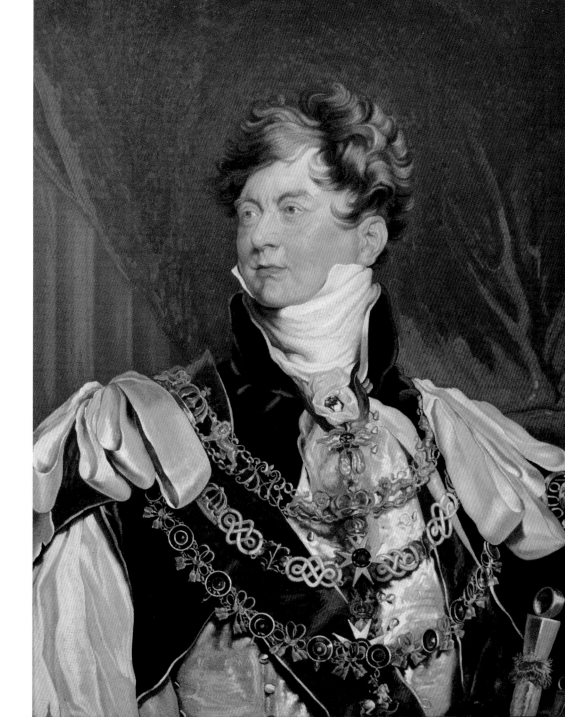

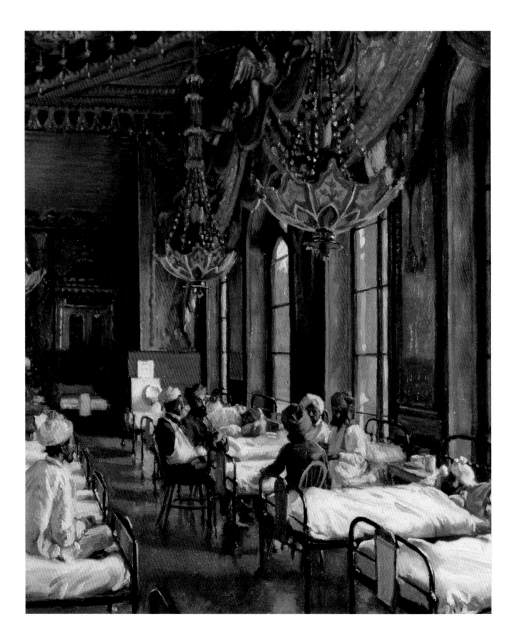

CHARLES HENRY HARRISON BURLEIGH, 1869–1956

The Music Room of the Royal Pavilion as a Hospital for Indian Soldiers, 1914–15

Oil on canvas, 69.5 × 56.5 cm

Purchased by Brighton Museum from C.H.H. Burleigh in 1916

FA000311

THE ROYAL PAVILION TOOK ON a very particular and notable role during the First World War, when it was converted into a military hospital. It was first used by soldiers of the Indian Army who had fallen injured or sick while fighting for the British on the Western Front.

The hospital opened in December 1914, when Indian soldiers made up about a quarter of the British Expeditionary Force to Belgium and France. Keen to maintain Indian loyalty, the British authorities promoted the Royal Pavilion as a symbol of imperial benevolence. Photographs of Indian soldiers treated in palatial wards were circulated as postcards throughout Britain and India.

Burleigh's painting tells a different story about the hospital. Unlike the monochrome photographs, he makes full use of his palette to depict the Pavilion's Music Room. He captures the vivid reds and greens, along with the different colours and styles of the patients' turbans.

Burleigh was not commissioned to create this painting and seems to have gained access only through local connections. While the photographs were carefully posed for political effect, he depicts a mood of calm recuperation: the men are resting in bed or chatting and relaxing. Away from the propaganda and violence of the war, this is a simple scene of men recovering in peace.

The Indian Army was gradually withdrawn from the Western Front to fight in the Middle East and the Royal Pavilion hospital closed in January 1916 before reopening a few months later as a hospital for British amputee soldiers. Hundreds of local people paid to visit the empty wards, and ticket sales supported the purchase of this painting for the town.

EDWARD FOX JUNIOR, FL.1851–1892

Fishermen on Brighton Beach, early 1860s

Albumen print on paper, 21 × 16.5 cm

Transferred to Brighton Museum & Art Gallery by Brighton City Libraries in 2002

BH400134

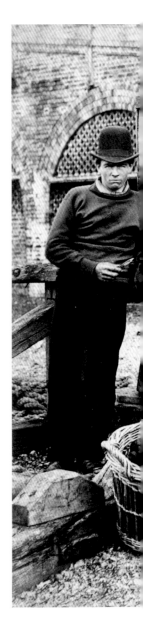

EDWARD FOX JUNIOR WAS the son of a Brighton painter. He followed his father in capturing the local landscape but focused his efforts on photography. At a time when most photographers made a living by taking portraits in studios, Fox specialised in outdoor photography. In the early 1860s he created a series of albumen prints capturing fishermen at work on Brighton beach.

This image is not only one of the earliest surviving photographs of Brighton, but also a reminder of the town's oldest industry. By the 1860s, Brighton was Britain's largest seaside resort, establishing a model that was emulated throughout the country and internationally. That success was based on visitors seeking health cures and entertainment, but it had come at the cost of many long-standing fishing families being pushed to the margins. Working from small patches of the beach, these fishermen were often living in poor-quality housing squeezed behind more affluent residences.

Away from the fashionable visitors and day-trippers coming to view or dip in the sea, Fox's photograph reminds us that these fishermen had been carrying out hard and sometimes dangerous work for generations. They would remain long after the visitors had left.

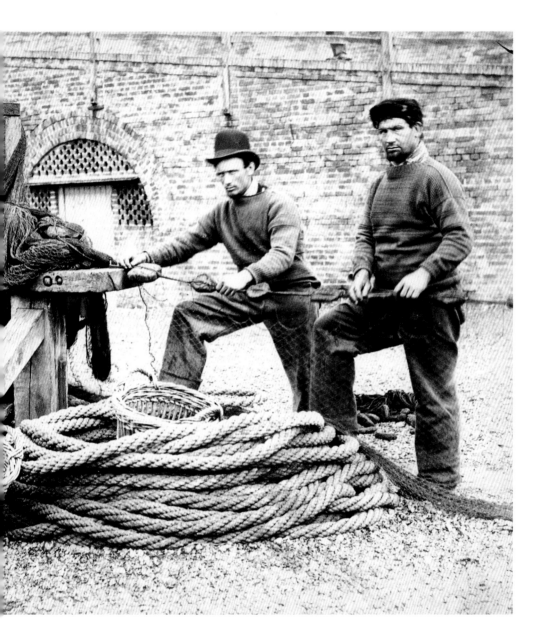

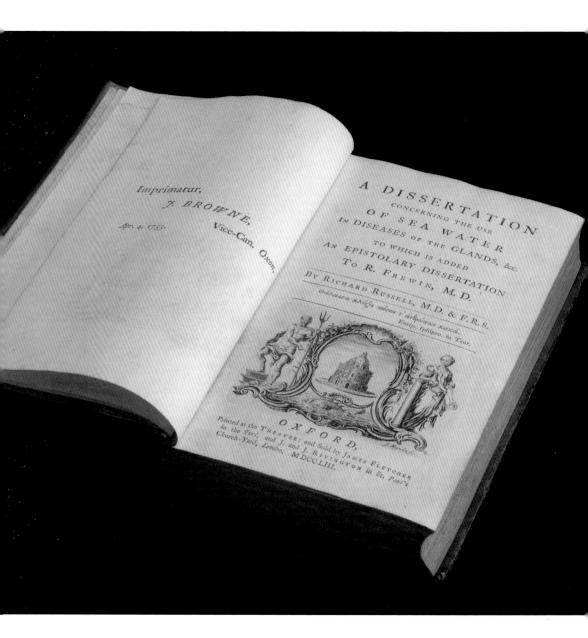

Imprimatur,

J. BROWNE,

Vice-Can. Oxon.

Apr. 4. 1753.

A DISSERTATION

CONCERNING THE USE

OF SEA WATER

In DISEASES of the GLANDS, &c.

TO WHICH IS ADDED

AN EPISTOLARY DISSERTATION

To R. FREWIN, M. D.

By RICHARD RUSSELL, M.D. & F.R.S.

Θάλασσα κλύζει πάντα τ᾽ ἀνθρώπων κακά.

Eurip. Iphigen. in Taur.

OXFORD,

Printed at the THEATRE; and Sold by JAMES FLETCHER in the *Turl,* and J. and J. RIVINGTON in St. *Paul's* Church-Yard, *London.* MDCCLIII.

RICHARD RUSSELL, 1687–1759

'A Dissertation Concerning the Use of Seawater in the Diseases of the Glands',
published 1753
Paper, card, leather, 20 × 13 × 4 cm
HA106842

BENJAMIN WILSON, FRS, 1721–1788

Dr Richard Russell FRS,
*c.*1755
Oil on canvas, 126 × 100.5 cm
Donated to Brighton Museum by Alderman Ridley
and R. Bacon in 1898
FA000016

BRIGHTON, OR BRIGHTHELMSTON AS IT WAS once known, was 'miserably torn to pieces, and made the very picture of desolation' wrote Daniel Defoe in 1704, the result of a series of fierce storms and a declining fishing industry. Yet within the space of half a century, Brighton's fortunes were revived thanks to Dr Richard Russell.

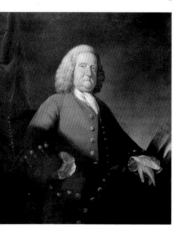

In 1750, Russell published 'De tabe glandulari...', a dissertation recording his experience of using sea water to treat glandular disease that was favourably received across Europe. Russell was recognised and elected a fellow of the Royal Society in 1752. The following year, this work was translated from Latin into English, a copy of which can be seen at Brighton Museum & Art Gallery. While Russell does not explain in his writings how seawater healed his patients, many probably benefitted from bathing in the cool seas and taking in cleaner air.

Wilson's portrait shows the now-famous doctor sitting proudly wearing a grey wig, a copy of his magnum opus propped open near his left hand with the viewer invited to marvel at the man and his achievements.

With demand for his treatments rising, Russell moved to Brighton from his birthplace in Lewes, eight miles inland. His newly built Brighton home had a prime position on the shoreline from which he could prescribe therapies of sea bathing and drinking seawater. Patronage of increasingly affluent persons helped establish Brighton as the forerunner of today's seaside resorts.

Russell was affectionately bestowed the moniker 'Doctor Brighton' and the town would become 'The Queen of Watering Places'. 'If you seek his monument, look around', a commemorative plaque proclaims on the site of the doctor's former home.

BRITISH SCHOOL

Portrait of Martha Gunn (1726–1815), *c.*1790

Oil on canvas, 91 × 70 cm

Donated to Brighton Museum & Art Gallery by Christopher Gunn in 2008

FA001251

'QUEEN OF THE BRIGHTON DIPPERS', Martha Gunn's long life ran in parallel with the development of Brighton from a fishing town into a fashionable seaside resort. An ever-present figure on the town's foreshore, she aided wary souls into the sea to partake in the new health kick of sea bathing, vigorously plunging her subjects beneath Brighton's waves.

Martha Gunn was known by all and a favourite of many – including the Prince of Wales, later George IV. Her celebrity locally was equal to his, and she supposedly remarked in her later years that 'I think I ought to be proud, for I've as many bows from man, woman and child as the Prince hisself; aye, I do believe, the very dogs in the town know me'.

She was immortalised in several artworks at the turn of the nineteenth century, including this fine oil painting by an unknown artist. It was donated to the museum in 2008 by Christopher Gunn, a direct descendant of Martha. The painting has had an incredible life of its own, having followed the Gunn family across continents, before the family eventually settled in Australia. Considering the distances this painting has travelled and the tropical environments it has lived in, it has survived remarkably well.

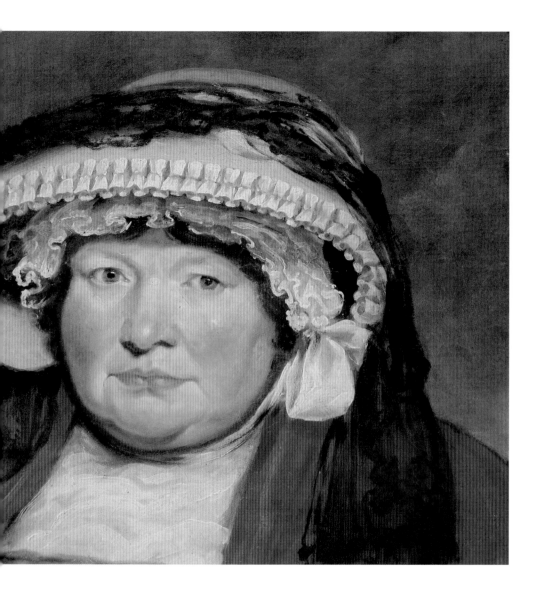

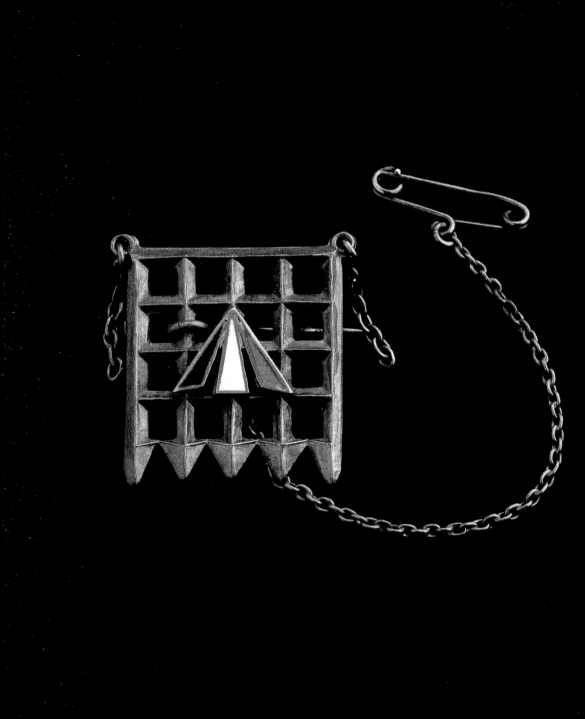

Ada Schofield, *c*.1859–1937

Minnie Turner (c.1867–1948),
c.1920

Gelatin silver print on card, 14.5 × 19 cm

Donated to Royal Pavilion & Museums, Brighton and
Hove by Gillian Robertson in 2014

R5982/11

Toye & Co.

Holloway brooch, *c*.1912

Silver, enamel

Donated to Royal Pavilion & Museums, Brighton and
Hove by Gillian Robertson in 2014

R5982/16

Brighton is proud of its reputation for progressive thinking and campaigning. Local activist Minnie Turner was a member of the Women's Social and Political Union (WSPU) and took direct action in support of the campaign for votes for women.

Turner ran a guesthouse known as 'Sea View', at 13 Victoria Road, Brighton, which she advertised in activist magazines including *The Suffragette* and *The Women's Dreadnought*. Leading members of the WSPU, including Emmeline Pankhurst, Annie Kenney and Emily Wilding Davison stayed with her, as well as suffragettes recovering from illnesses caused by overwork or imprisonment, or while working for the WSPU in Sussex. Turner also organised fund-raising activities, ran a suffrage lending library and took part in demonstrations in London.

In November 1911, while protesting in London, Turner broke a window at the Home Office and was sentenced to prison for three weeks. On her release, she was awarded the Holloway Brooch, awarded to members of the WSPU who had been imprisoned. It was known as 'the Victoria Cross of the Union' and depicts the portcullis of the House of Commons, superimposed with a convict's arrow enamelled in the purple, white and green colours of the suffrage movement.

Minnie Turner continued to campaign for women's suffrage and social justice. She died in 1948 and was remembered as determined, fun-loving and warm. In 1918, the Representation of the People Act gave some women in the UK the right to vote. It was not until the 1928 Equal Franchise Act that women had equal voting rights with men.

Light for the Blind, 1877
Dr William Moon (1818–1894), published by
Longmans, Green & Co. (London)
Paper, card, photographic paper, textile, gilt
DB70[83]

BRIGHTON AND HOVE HAS BEEN HOME to many charitable and innovative individuals and institutions that have dedicated their work to improving the lives of disabled people. Dr William Moon is held in high esteem for his invention that gave 'light to eyes that cannot see'. Moon was born in Horsmonden, Kent, in 1818. Aged four, he contracted scarlet fever and lost the sight in one eye. By the age of 21, he was totally blind. Abandoning his ambitions to become a minister, he began to teach blind adults and children to read in Brighton.

The reading systems available in the 1830s were complex and difficult for some of Moon's pupils to grasp, particularly those whose hands were calloused from manual labour. He set about creating a simpler alphabet based on modified Roman letters, inventing 'Dr Moon's Alphabet for the Blind'.

Moon began publishing works alongside his teaching, including reading guides, bibles, maps and illustrations. In 1856, with the support of his friend and benefactor Sir Charles Lowther, his Brighton home was expanded to include a printing press which gave employment to blind workers. The expanded enterprise enabled the distribution of books across the world. Lowther, who was blind himself, took 2,000 volumes to New York for distribution across the US. By the time Moon died in 1894, over five hundred foreign alphabets had been converted to 'Moon'.

Although the Moon system was overtaken in popularity by Braille, William Moon is remembered for his pioneering work concerning the welfare and education of blind people. He was awarded an honorary degree by the University of Philadelphia in 1871.

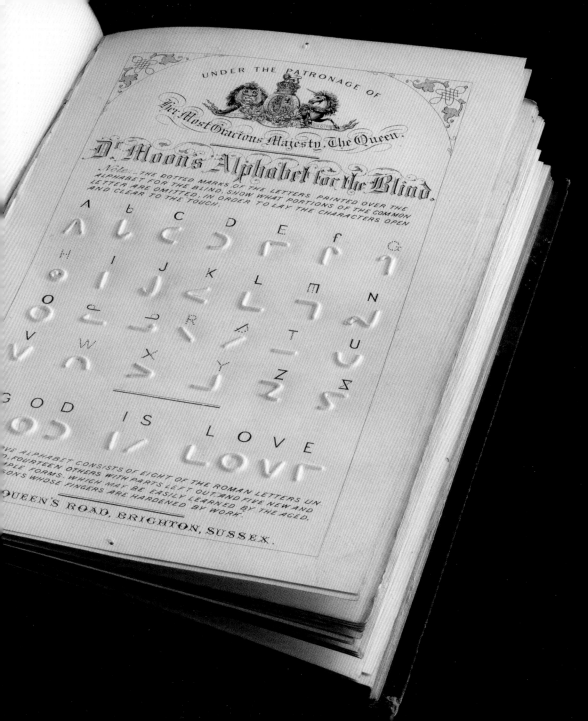

UNDER THE PATRONAGE OF

Her Most Gracious Majesty, The Queen.

Dr Moon's Alphabet for the Blind.

Note.— THE DOTTED MARKS OF THE LETTERS, PRINTED OVER THE ALPHABET FOR THE BLIND, SHOW WHAT PORTIONS OF THE COMMON LETTER ARE OMITTED, IN ORDER TO LAY THE CHARACTERS OPEN AND CLEAR TO THE TOUCH.

A B C D E F G
H I J K L M N
O P Q R S T U
V W X Y Z

GOD IS LOVE

THE ALPHABET CONSISTS OF EIGHT OF THE ROMAN LETTERS UN... FOURTEEN OTHERS WITH PARTS LEFT OUT, AND FIVE NEW AND ...PLE FORMS, WHICH MAY BE EASILY LEARNED BY THE AGED, ...SONS WHOSE FINGERS ARE HARDENED BY WORK.

QUEEN'S ROAD, BRIGHTON, SUSSEX.

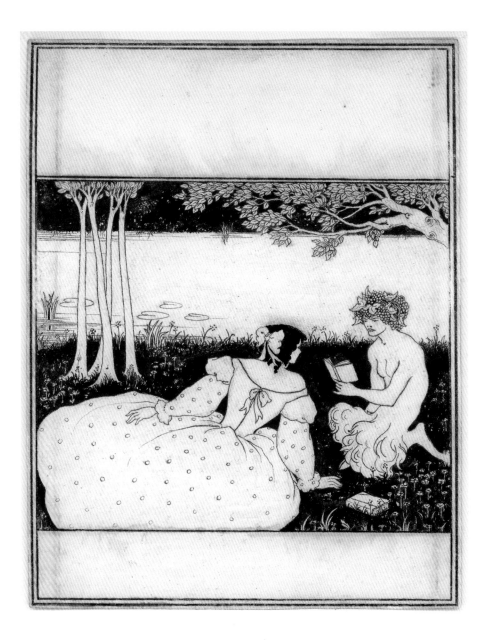

Aubrey Beardsley, 1872–1898

Cover design for Volume V of The Yellow Book, 1895

Pen and ink, 12.5 × 15.3 cm

Donated to Brighton Museum & Art Gallery by John Lane, 1926

FA100365

If Brighton is known for its progressive political campaigning and charitable works, it is also known for avant-garde arts and decadence. Aubrey Beardsley was born in Brighton; aged seven, he was diagnosed with tuberculosis. He attended Brighton Grammar School until 1888, when he joined his family in London. He left his position as an insurance clerk to become a full-time artist. Beardsley died aged just 25, but he had productive career, with his highly original work making a significant impact on the history of art.

Beardsley's black-and-white illustrations and association with Oscar Wilde and the Decadent movement of the 1890s made him notorious. By early 1895, Beardsley had success with *The Yellow Book*, a quarterly journal he had founded with the American novelist Henry Harland. The first four volumes of *The Yellow Book* all bore intriguing cover pictures by him, striking in both style and moral tone. Using yellow alluded to the covers of contemporary French novels and considered by many to be 'risqué' literature.

The drawing here shows an idyllic scene influenced by Antoine Watteau's *fête galante* paintings, but tainted with Beardsley's sinister twist. A young, unchaperoned woman listens intently while a satyr – symbolic of lasciviousness and intoxication – reads to her. The framing of the drawing and the blank bands at the top and bottom accommodate the magazine cover template.

This design, for Volume V, was never published. On 5 April, Wilde was arrested for gross indecency, apparently carrying a copy of *The Yellow Book* under his arm. This association dealt a cruel blow: Beardsley was sacked and his cover design replaced. The drawing was given to Brighton Museum by John Lane of The Bodley Head publishing house, which published *The Yellow Book* between 1894 and 1897.

PHILIPPE DE CHAMPAIGNE, 1602–1674

St Veronica's Veil, c.1640

Oil on canvas, 64.5 × 49 cm

Donated to Brighton Museum & Art Gallery by Miss Mary E. Hickman in 1933

FA000171

BRIGHTON MUSEUM & ART GALLERY opened in 1873 and important bequests of paintings followed soon after. By the early 1900s, some of the most important pictures in the collection were by Flemish and Netherlandish artists, and when this painting was donated in 1933, it was thought to belong to the sixteenth-century Flemish school. In 1976 it was reattributed to the French artist Philippe de Champaigne, who became the leading portrait painter under Louis XIII, as well as one of the greatest religious history painters of the seventeenth century. The hyperreality of the image makes it one of the most striking paintings in the museum's collection.

This devotional painting depicts the holy relic known as the Veil of Veronica. According to Christian tradition, St Veronica was moved by the sight of Jesus carrying the cross to Calvary and gave him her veil to wipe his forehead. When he returned the veil, it was imprinted with an image of his face. Since the eleventh century, the Veil of Veronica has been recorded as being in St Peter's Basilica in Rome and an image still there today is said to be the Veil, displayed each year on Passion Sunday.

Champaigne's detailed observation of the Veil aimed to create an image that would inspire meditation on Christ's suffering. The white cloth bearing the imprint of Christ's face with a crown of thorns and vividly depicted drops of blood and tears is shown behind a curtain in an alcove, the realism transforming the painting into a three-dimensional object. Champaigne painted four versions of this powerful image.

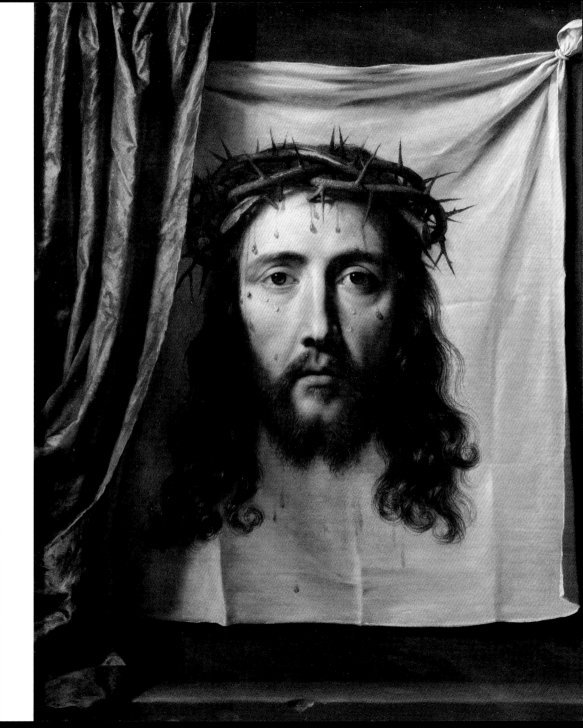

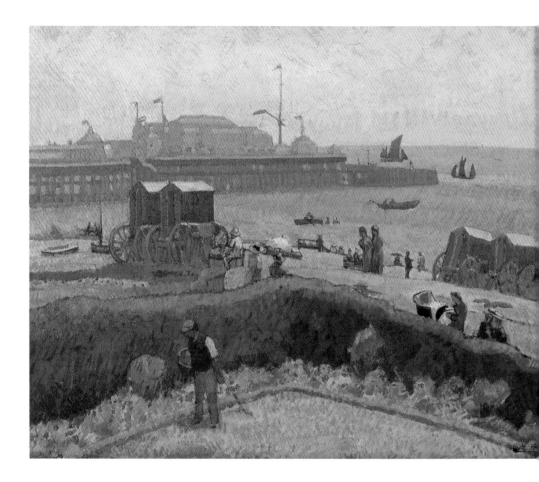

SPENCER GORE, 1878–1914

The West Pier, Brighton, 1913

Oil on canvas, 64 × 77 cm

Acquired in 2019 with support from the National
Heritage Memorial Fund, Art Fund, Arts Council
England/V&A Purchase Grant Fund, the Thompson
Bequest, The Royal Pavilion & Museums Foundation,
Daniel Katz Ltd., Mr Stephen Pavey, Patrons of the
Royal Pavilion & Museums, supporters of the West
Pier Trust and anonymous donors.

FA001273

WALTER TAYLOR, 1860–1943

Two Figures in an Interior in Brunswick Square, c.1925

Oil on canvas, 63.5 × 76.2 cm

Purchased by Hove Museum & Art Gallery with
assistance from the MGC / V&A Purchase Grant
Fund in 1995

FAH1995.43

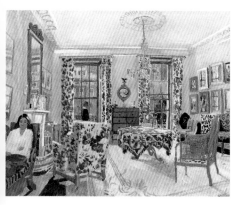

SPENCER GORE WAS A FOUNDING member of the Camden Town Group of painters (1911–13). The London-based group, all male artists, produced work characterised by everyday subject matter and a first-hand description of form, space and light – all influenced by French post-impressionism.

In the summer of 1913 Gore and his family stayed in Brunswick Square on Hove seafront, at the home of his friend and patron, Walter Taylor, who was an artist himself and collector of Camden Town Group paintings. Gore painted *The West Pier, Brighton* and a very similar view, *Brighton Pier* (Southampton City Art Gallery), from the first-floor balcony of Taylor's house. In both paintings he used bright colours and blocky forms to depict the experience of modern life. Taylor had spent time in France not only painting but also collecting modern French art. His painting of an interior in his house reflects his interest in paintings by Edgar Degas and by Edouard Vuillard, and some of his collection can be seen in this painting.

Gore's iconic painting of Brighton, painted shortly before his early death is regarded as one of his masterpieces. It was included in the celebrated *Exhibition by the Camden Town Group and Others* held at the Public Art Galleries (Brighton Museum & Art Gallery) in 1913–14. This was the Camden Town Group's only exhibition outside London and the first occasion that English post-impressionist work had been seen outside the capital.

MALAGAN SCULPTURE MADE BY AN UNKNOWN MALE
MASTER MALAGAN CARVER

Big-Mouth Fish, *c.*1925–28

Nalik region, New Ireland Province, Papua New Guinea, Oceania
Collected by William Edwin Sansom, Australian Patrol Officer in New Guinea. Donated in 1931 by Mrs Sansom.
Brighton Museum & Art Gallery
WA504090

BRIGHTON & HOVE MUSEUMS holds a significant collection of world art. The collection and associated activities receive important support from the James Henry Green Trust. The most notable collections are those from across Africa and Oceania. This object and the kente textile (pages 50–51) reflect both historic colonial collecting from Papua New Guinea, and contemporary collecting initiatives embarking on decolonial practice with partners from Africa and the diaspora.

Malagan carvings such as this one from New Ireland are displayed at memorial ceremonies following a funeral. The term 'Malagan' refers to both the ceremony and the sculptures and masks made for the event. Malagan are joyful, celebratory occasions that link the living and the dead.

This dramatic wooden sculpture depicts a giant winged fish with a human figure fixed to its mouth. The fish is a grouper (or 'big mouth' fish) called Bulavai. The fish-and-figure design originates from a legend about a fisherman, Lamesisi, who was brought back to life after being swallowed by Bulavai. Being swallowed by a giant fish is a symbol of death and when someone dies, people may say 'big-mouth got him'.

Malagan carvings are commissioned by families and the colourful designs are rich in symbolic meaning. Malagan are made by master carvers, internationally renowned for their skill. Although great cultural value is placed on these sculptures they are not needed after the ceremony has taken place, so were frequently acquired by colonial officials and travellers, and displayed in western museums.

'This malagan represents our clan … It was carved in certain steps. It uses special writing. Every colour is a word or saying.' Memaai (orator) Julius Bokawa Laisie

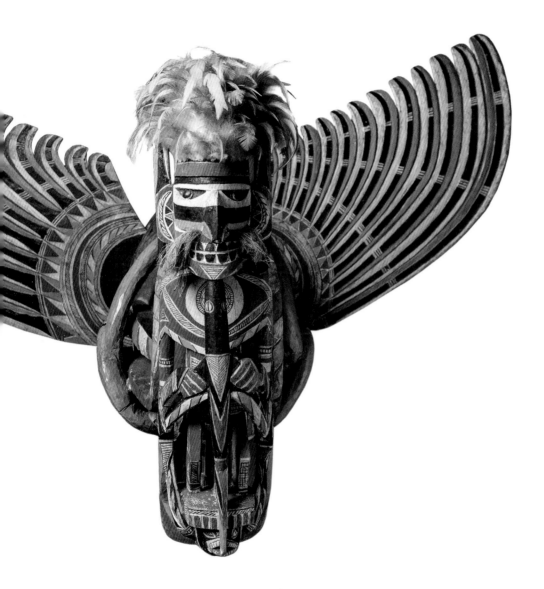

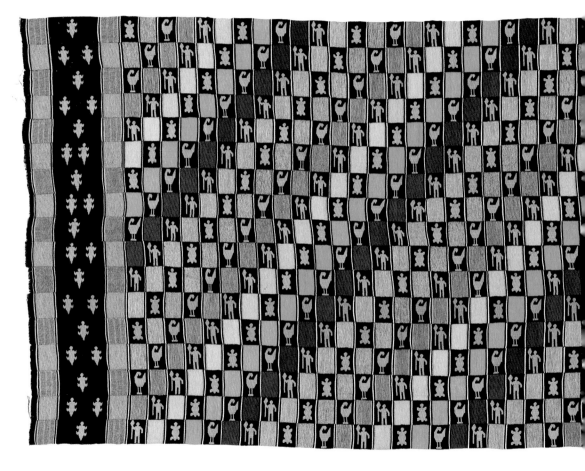

FRED AKPO AND RICHMOND AKPO, 2017

Textile, Kente

Agotime Kpetoe, Adaklu-Anyigbe district, Volta region, Ghana, Africa

Collected by Rachel Heminway Hurst, Curator of World Art, on a research trip to Ghana as part of 'Fashioning Africa' project in 2017.

Brighton Museum & Art Gallery and https://fashioningafrica.brightonmuseums.org

R6080/1

THE PRACTICE OF KENTE ORIGINATED IN GHANA and has great cultural significance for both Ewe and Ashanti peoples, recently acquiring worldwide admiration. Traditionally kente is woven by men in narrow strips on horizontal looms. Strips are sewn together to produce large wrappers made for men and pairs of smaller cloths for women. Ewe weaving is centred around the towns of Kpetoe and Agbozume, where kente-weaving workshops produce both commissioned cloths for special occasions and cheaper cloths for sale at local markets.

This distinctive textile is an item of clothing made from narrow strip woven kente, known as design cloth or Adanouvor. It was designed and woven by twins Fred and Richmond Akpo, who have Ewe heritage. Kente production among the Ewe people from eastern Ghana has an enduring and rich history.

This textile is a replica of the cloth that won the Akpo twins the 2016 Agotime Kpetoe Kente Festival weaving and design competition. It consists of 17 strips and employs two distinctly Ewe techniques to create a series of figures and animals and blocks of mixed colours that create a shimmer effect.

The twins set up their own weaving workshop when still in their twenties, allowing them to support their family and pass on their skills to other young men and boys, and to develop their business by focusing on designing new award-winning cloths. The twins represent a new generation of Ewe kente designers and weavers.

'We just would like you to tell people that we are here and tell them about our kente cloths.'

Quote from interview with Fred and Richmond Akpo, 2017.

The Jaipur Gate, 1886

Designed by Colonel Samuel Swinton Jacob, 1841–1917, and Surgeon-Major Thomas Holbein Hendley, 1847–1917. Carved by Shekhawati craftsmen, Rajasthan, India

Teak

Donated to Hove Museum & Art Gallery in 1926

WATMP000150

THE JAIPUR GATE WAS PRESENTED TO Hove Museum of Creativity in 1926 by the Imperial Institute. The Gate has been on display at Hove Museum's current site at Brooker Hall since it opened to the public in 1927.

The gateway was created for the Colonial and Indian Exhibition held at South Kensington, London in 1886. It formed the central portion of the eastern Exhibition Road entrance to the Indian artware courts. The Maharaja of Jaipur paid for the construction of the gate which, although carved and assembled by Indian craftsmen, is a hybrid construction designed by two Englishmen, Colonel Samuel Swinton Jacob and Surgeon-Major Thomas Holbein Hendley, combining elements found in Mughal and Rajput buildings. The inscription on the front, in English, Sanskrit and Latin, is the motto of the Maharajas of Jaipur – 'where virtue is, there is victory'. The Latin inscription on the back reads 'from the east comes light'.

The wood used is teak, cut and joined in Bombay and then sent to Jaipur to be carved by Shekhawati carpenters. The general design is the modified Saracenic architectural style which was in vogue in what was then called Upper India and Rajputana.

The Jaipur Gate may be viewed as an example of British imperialism, presenting India as an exotic artisan nation benefitting from British patronage. However, the unmistakable resemblance to the sixteenth-century Panch Mahal palace in the Mughal capital Fatehpur Sikri, suggests the designers were well aware of the artistic legacy to which they were indebted. Hove was seen as a fitting location for the gate due it being a popular retirement destination for Indian Army officers and civil servants.

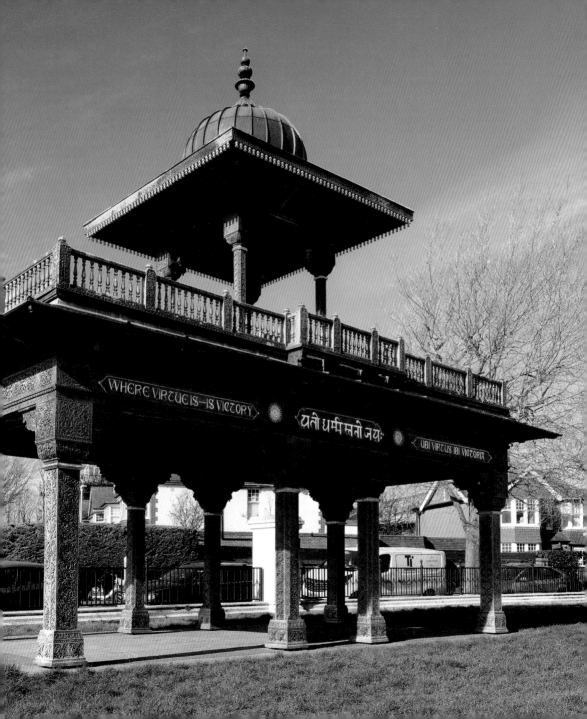

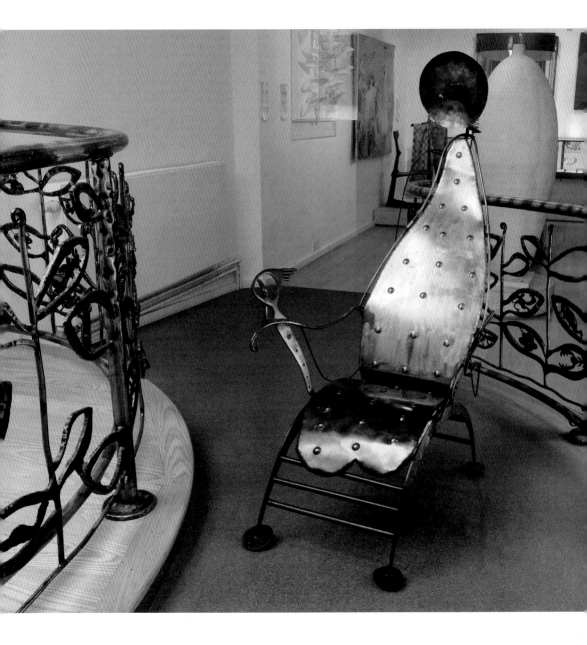

JON MILLS, 1959–

Dan Dare Chair, 1987

Mild steel, coated steel cable, 165 × 64 × 92 cm
Purchased by Hove Museum & Art Gallery in 1993 for the South East Arts Craft Collection
C4.1993

HOVE MUSEUM OF CREATIVITY HOLDS important craft collections, and these include the first version of Jon Mills's *Dan Dare Chair*. This space-age chair is among several furniture designs by Mills in which 'function takes a back seat'. With its mild-steel, winged-style levers, wire cables and directional, removable radar dish, the chair was inspired by 1950s pop culture. It was named after Dan Dare, 'Pilot of the Future', a chisel-jawed British science-fiction hero, who appeared in the Eagle comic (1950–69). The chair was first exhibited in the Crafts Council's New Spirit in Craft & Design touring exhibition in 1987 and purchased by Hove Museum of Creativity for the South-East Arts Craft Collection in 1993. Both the chair and the railings next to it were made by Mills with school children.

Jon Mills was born in Birmingham and comes from a long line of metalworkers. He studied in Wolverhampton before helping to found Brighton's Red Herring Studios in 1983. His work is influenced by the blacksmiths he had seen working in the Black Country and ranges from automata pieces to large-scale public works, sculpture and architectural commissions. Brighton & Hove Museums has another of Mills's dynamic metal sculptures, *Man in a Plane*.

KATE MALONE, 1959–

Pumpkin Teapot, 1996–97

Stoneware, 28 × 44 cm

Purchased by Hove Museum & Art Gallery in 1997

H1.1997

THE CONTEMPORARY CRAFT Collection at Hove Museum of Creativity is renowned for innovative and quality works by significant makers, many of which were collected at early stages of the maker's career.

Among this collection Kate Malone's stoneware *Pumpkin Teapot* provides a visual celebration and imaginative feast for the eyes. Malone is well known for her ceramic organic forms inspired directly from nature including gourds, pineapples, pumpkins and berries. She transforms the clay into voluptuous vessels which suggest the fecundity of nature and then adds playful vibrant ornamentation. Her works are strongly sculptural and, while seemingly about the natural world, they also appear as human beings with unique personalities embodying human idiosyncrasies.

Although made early in her career, the Pumpkin Teapot is still instantly recognisable as Malone's work, incorporating the distinctive characteristics of many of her pieces. The large rounded buxom form of the pumpkin bursts with ripeness, celebrating nature's fertility. The addition of the teapot handle and spout, together with the use of the pumpkin stalk adds a surreal element. The piece alludes to the magical pumpkin in Cinderella although Malone also created another teapot *Cinderella's Carriage* directly referencing the fairy tale.

The piece was made from a plaster mould, which Malone created by using hand coiling. It is covered in a yellow crystalline glaze, a technique she developed where crystals grow inside the glaze on the surface of her pots. Malone's fascination and experimentation with new glazing techniques is an integral part of her work.

Kate Malone was born in London and studied ceramics at Bristol Polytechnic and the Royal College of Art.

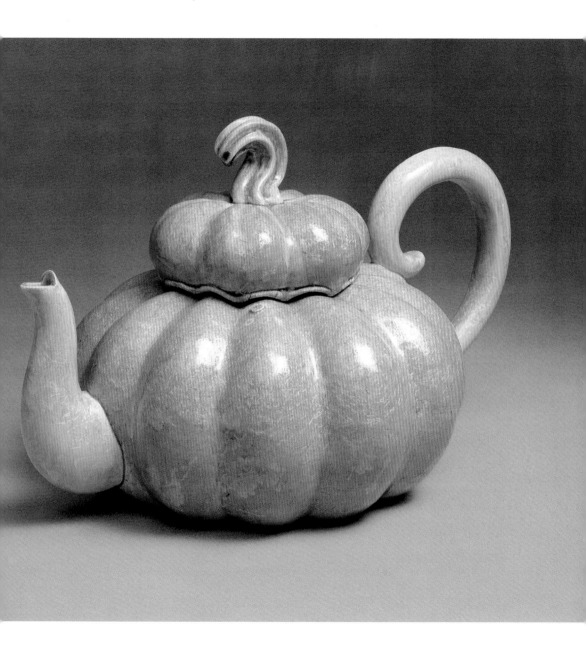

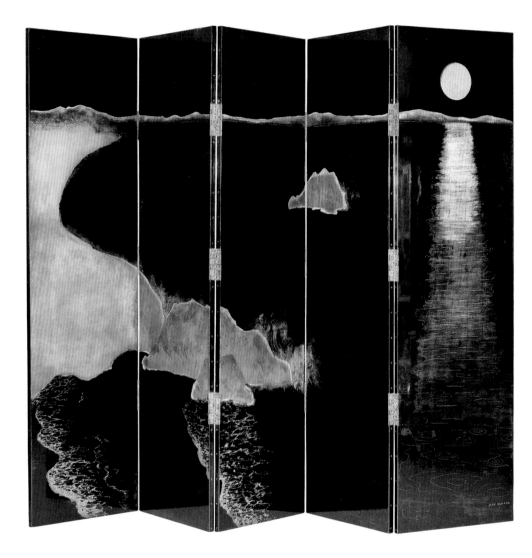

JEAN DUNAND, 1877–1942

*Clair de Lune, c.*1928

Wood, lacquer, vellum, silver, 225 × 312.5 × 5 cm

Purchased by Brighton Museum & Art Gallery in 1979 with the support of the Friends of the Royal Pavilion and the V&A Purchase Grant Fund

DA300456

BRIGHTON & HOVE MUSEUMS has an internationally important collection of twentieth-century decorative arts, its display forming the centrepiece of Brighton Museum & Art Gallery. The Swiss artist and designer Jean Dunand believed that the finest results were achieved during the full moon. His five-leaf screen, *Clair de Lune*, made in France, depicts a night seascape with the moon reflected in the water. The mood is intensified by the lustrous shine of the black lacquered wood and silver additions.

The high viewpoint of the folding screen demonstrates the influence of Japanese woodcut prints. Dunand was fascinated by Chinese and Japanese crafts and studied the ancient, laborious techniques of lacquering from Seizo Sugawara (1884–1937), the Japanese lacquer master who was living in Paris at the time.

The high-gloss finish of the screen was achieved through the application of many layers of iron-oxidised black lacquer, onto a wood base, each coating dried and polished before the next was added. The process would have taken place in a damp room, which provided the necessary humidity and prevented dust particles settling on the lacquer. The watery conditions of the screen's creation form a connection with the sea depicted on the shiny surface.

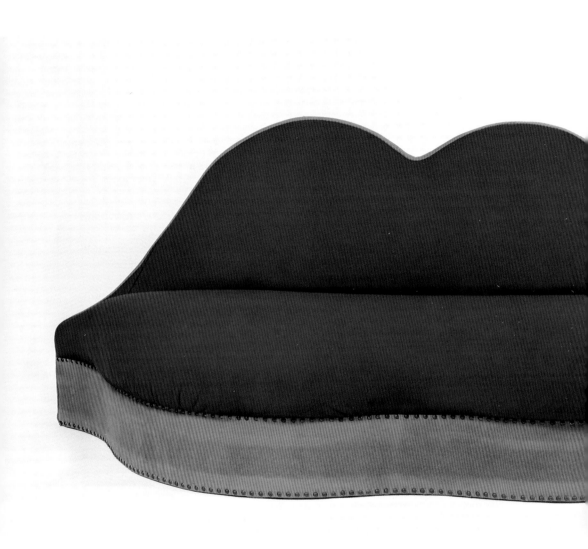

Salvador Dalí, 1904–1989, and Edward James, 1907–1984

Mae West's Lips sofa, 1938

Wool felt and wood, 92 × 213 × 80 cm

Manufactured by Green & Abbott

Purchased by Brighton Museum & Art Gallery from the Edward James Foundation in 1983 with the support of Charles Robertson and the V&A Purchase Grant Fund

DA300594

Edward James (1907–1984), the generous and eccentric Surrealist patron and owner of West Dean House on the outskirts of Chichester, had a profound influence on Brighton Museum & Art Gallery in the 1960s and 70s. His friendship with Clifford Musgrave (1904–1982), the then-Director, led to a decade-long loan of Surrealist paintings filling the walls of the current 20th-Century Gallery. In 1983, soon after the loan ended, the museum purchased Edward James's and Salvador Dalí's iconic *Mae West Lips* sofa, adding to the significant number of objects already donated to the museum by James.

James established often tempestuous friendships with an astonishing number of artists, many of them Surrealist, supporting their work through his purchases. In 1936, he contracted to buy all of Dalí's work for a year. He also proposed that together they create a Surrealist interior for James's grand London house in Wimpole Street. Using Dalí's painting *Mae West's Face Which May Be Used as a Surrealist Apartment* (1934–35) as inspiration, they designed the *Lips* sofa with James deciding the final shapes and upholstery of the five examples he commissioned for himself.

James and Dalí's ideas for a Surrealist interior developed into the remodelling of James's country house, Monkton, on the West Dean Estate, into a Surrealist home, with carved draperies and palm trees on the purple exterior, padded walls in the drawing room; and his dog's paw prints woven into the design of the stairway carpet. Two of the *Lips* sofas were kept there – a third, covered in pink satin matching the couturier Elsa Schiaparelli's (1890–1973) characteristic shocking lipstick, was kept in the dining room at Wimpole Street.

St John Child

Brummel the cat, 1991

Plaster, wood, 197 × 96.5 × 76 cm

Unaccessioned

Emile Galle, 1846–1904

Cat figures, *c.*1880

Glazed earthenware, 33 × 13 × 18 cm

Donated to Brighton Museum & Art Gallery

by Mrs Battersby in 1976

DA300041, DA300042

THE LARGE PLASTER CAT, WELCOMING VISITORS to Brighton Museum & Art Gallery, conceals a donation box designed to 'purr' on receipt of coins. In 2002 BBC Southern Counties Radio listeners named it 'Brummel' in honour of the famous dandy, George Bryan 'Beau' Brummell (1778–1840).

'Brummel' was made by St John Child, who worked in the museum's design department in the 1970s and 80s. He based his design on this pair of enamelled faience cats in the Decorative Art collection. They were created by Emile Gallé, the French artist and designer who was acclaimed as one of the leaders of the Art Nouveau movement in France.

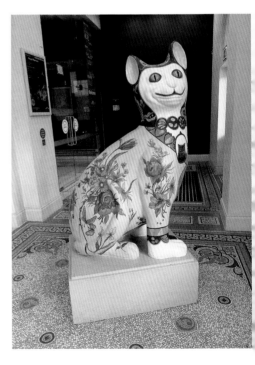

These popular smiling cats have green glass eyes, black lace bonnets and bright hand-painted chintz kimonos, one blue, the other yellow. Each figure wears a locket with a portrait of a canine lover. The cats were made in Gallé's factory in Nancy, France. The model for these creations underwent a gradual metamorphosis from early protypes, with form and decoration suggestive of Staffordshire agateware pottery, to the later models, such as these vibrant polychrome examples inspired by Delftware. They in turn led to the many modern ceramic versions of the Gallé cats and inspired the museum's much-loved moneybox.

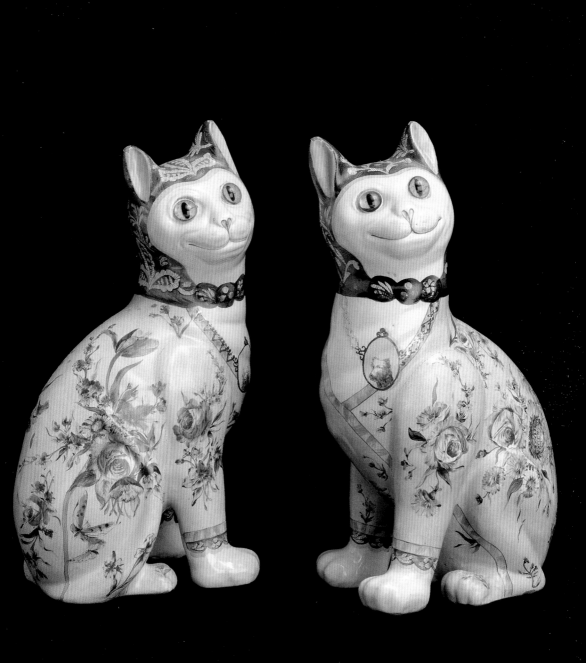

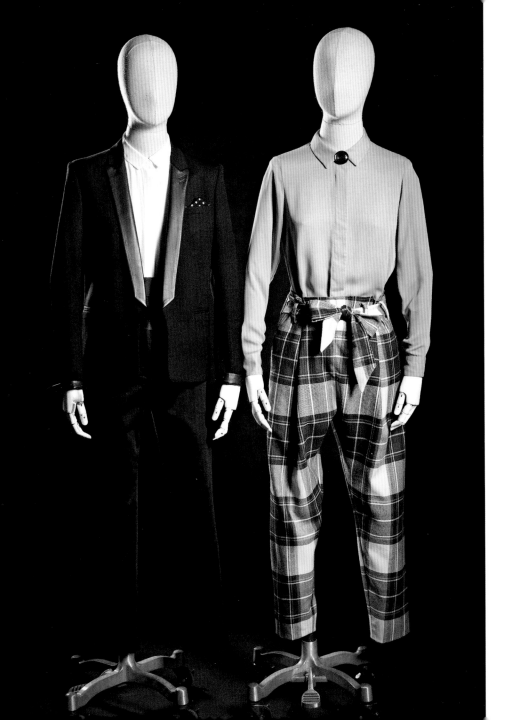

Wedding outfit, 2015

Ciara Green: trouser tuxedo, white shirt, Dr Marten shoes
Abbie Lockyer: check trousers, blouse, neck jewel, Dr Marten shoes
Acquired by Brighton Museum & Art Gallery 2017
CCE0440.7

ANOTHER OF IMPORTANT ASPECT OF Brighton & Hove Museums collections surveys dress and fashions. Ciara said at the time of donating her and her wife's outfits to Brighton Museum & Art Gallery, 'We chose our wedding outfits together … We both value each other's opinion and share a similar style, so we were excited to shop together, but we also needed to ensure we didn't turn up to the big day in the same outfit!'

These two wedding outfits are part of the Queer Looks collection held by the Museum, which celebrates and documents Brighton's LGBTQ+ history. This collection of queer people's clothing together with their oral histories was created by the museum in 2017 to commemorate the fiftieth anniversary of the partial decriminalisation of homosexuality in England and Wales. The project was in partnership with the Centre for Fashion Curation at the London College of Fashion and was funded by the Heritage Lottery Fund, with the collection to be a permanent record of the queer lives of Brightonians over the last 50 years.

The Queer Looks display brought representation of Brighton's large and vibrant queer communities to the Museum. It also brought to museum audiences – many of whom are outside of the local area – the lives of individuals with whom they might not otherwise engage with, and it was hoped a greater understanding and empathy with LGBTQ+ history.

At the time of the Queer Looks project, same-sex marriage was still illegal in Ciara's country of birth, Northern Ireland. She said at the time, 'It sometimes feels overwhelming to think that our lives and relationships aren't seen as real or normal, not only on our own doorstep but actually in the majority of the world at present.'

EMANUEL NICHOLS AND
RAEL BROOK, 1948–

***Emanuel Nichols bespoke
blue tonik suit, Rael Brook
peach cotton shirt,*** *c.*1965

Mohair, cotton, metal and plastic
Donated to Royal Pavilion & Museums, Brighton &
Hove by David Cooke in 2001
CT003849, CT003850

JOHN LEWIS PLC

Customised black jacket, 1963

Leather, metal and enamel
Donated to Brighton Museum & Art Gallery by
Rockin' Bill in 2001
CT003956

IN 1964, FOLLOWING SOME MINOR CLASHES in Clacton, Essex, the British press stirred up 'moral panic' aimed at two youth sub-cultures – the style-conscious Mods, characterised by their fine suits and scooters, and the Rockers, identified by their leather jackets, boots and motorcycles.

In May that year, thousands of people swarmed to Brighton for the Whitsun bank holiday. Provoked by the media's sensationalised claims of violence between the two groups, two days of fighting ensued, resulting in the infamous scenes of flying stones and deckchairs on Brighton Beach. Rockin' Bill, whose leather jacket is pictured, recalls the 'little rumble' he and his friends got into on Brighton Aquarium's sun terrace: 'the only thing we could do was protect ourselves with deckchairs'.

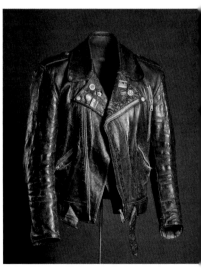

Their attackers weren't deemed to be real Mods, just gangs of kids dressed up and looking for a fight. No Mod would want to roll about in the dirt and ruin their expensive clothes which were hugely important in terms of their identity. This bespoke blue tonic suit is typical of the Mod look inspired by slim-fitting Italian tailoring. It is made of beautiful mohair cloth adding to the exclusivity of the outfit.

Inspired by the events in Brighton 1964, The Who released their third rock opera *Quadrophenia* in 1973. This in turn inspired the cult film, set in Brighton and released several years later to coincide with the Mod Revival movement in the late 1970s. To this day, scooters and motorbikes continue to line Brighton seafront on bank holiday weekends.

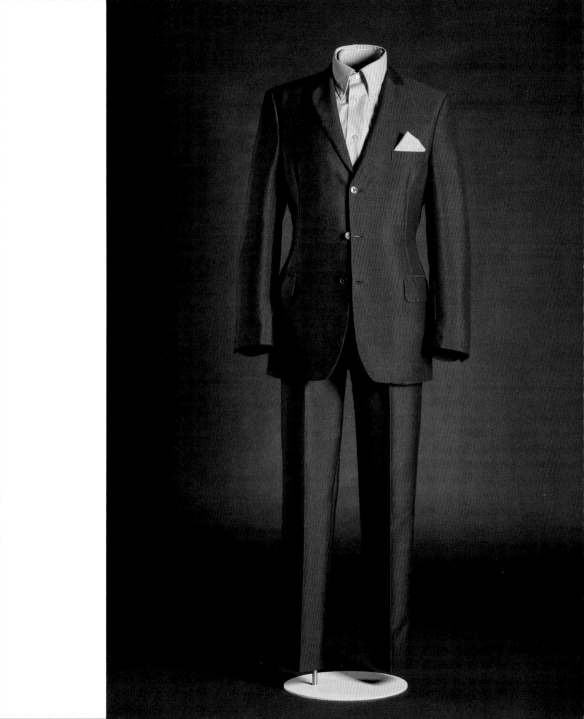

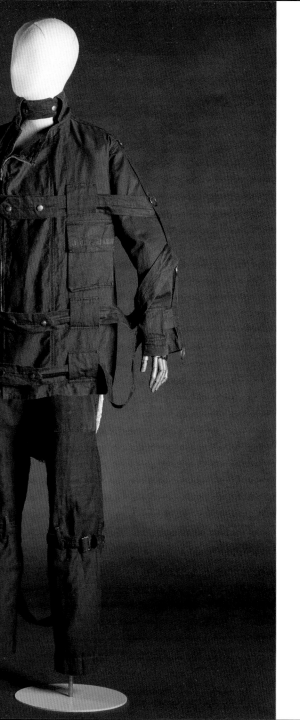

VIVIENNE WESTWOOD, 1941–, AND MALCOLM McLAREN, 1946–2010

Seditionaries bondage jacket and trousers, 1977

Cotton, metal R5911/6, R5911/7, R591 1/8

THROUGHOUT THE 1970S VIVIENNE WESTWOOD and Malcolm McLaren's clothing boutique on the King's Road, Chelsea was the focal point for music and the alternative fashion scene, and influenced a generation of musicians, designers and pop stars including the Sex Pistols, The Clash, Siouxsie and the Banshees, Adam Ant and Boy George. The boutique reincarnated itself numerous times over the decade in line with changes in street fashion – Let It Rock (1971), Too Fast to Live; Too Young to Die (1972), Sex (1974), Seditionaries (1977), and finally World's End (1980).

This outfit was worn by Tony Lord, a resident of Brighton, to punk gigs and clubs in the city in the late 1970s. He bought this outfit from Seditionaries, which was at the time the focus for London's punk movement. With a relatively small clientele, original examples of clothing from the King's Road boutique are rare. Such is the desirability for the original designs that there is now a thriving international market for fakes.

As a regular visitor to Seditionaries, Tony bought many T-shirts, outfits and accessories, including some of the most well-known designs of the period by Westwood and McLaren: 'Anarchy in the UK', '"Gay" Cowboys', 'Cambridge Rapist', 'Mickey and Minnie Mouse', 'Vive la Rock' and 'Destroy' muslin shirts, parachute shirts and bondage trousers.

Tony's collection of Seditionaries outfits was acquired by the Royal Pavilion & Museums in 2012 and are held in the fashion and textiles collection.

Arthur John Elsley, 1860–1952

Faithful and Fearless: Kylin, 1917

Oil on canvas, 45 × 54 cm

Bequeathed as part of the Stanford Bequest of Preston Manor & Gardens and its contents
to the Brighton Corporation in 1932

FAPM090065

Preston Manor & Gardens is on the outskirts of Brighton and on the edge of Preston Park, a much-loved open space. The eighteenth-century manor house containing paintings, furniture and decorative arts was given to the town of Brighton in 1932 by its former owners, Sir Charles and Lady Thomas Stanford. Just as Preston Park is popular with dog walkers, there is a strong dog theme to some of the bequest. The painting *Faithful and Fearless: Kylin* is by Arthur John Elsley, a British genre painter whose works featuring bucolic scenes of children and their pets were popular as reproduction prints.

Kylin, a Pekingese dog who lived between 1909 and 1924, was owned by Ellen Thomas-Stanford (1848–1932) who commissioned her beloved pet's portrait in 1917. Kylin's pedigree is ambiguous since her appearance suggests she may be an unusual Tibetan Spaniel cross. Her likely origin is the stable of Edwardian Pekingese breeders Lord and Lady Algernon Gordon-Lennox whose exclusive circle included socialite Evelyn Bennet-Stanford, Ellen's daughter-in-law. These names appear in Ellen's visitors' book in October 1909, indicating the gift of a puppy unsellable as pure Pekingese.

Following Kennel Club registration in 1910 Pekingese ownership accelerated in high society as an indicator of wealth and status to become the fashionable toy-dog breed of the Edwardian period. Breeders emphasised lineage direct to the Imperial palaces of Tang dynasty China causing European and American Pekingese owners to give their dogs Chinese names, real or fantastical. One of the few known dogs to survive the sinking of RMS *Titanic* in 1912 was a Pekingese named Sun Yat-Sen. Kylin is a whimsical generic word used by Victorian dealers to describe Chinese animal figurines and other East Asian collectables.

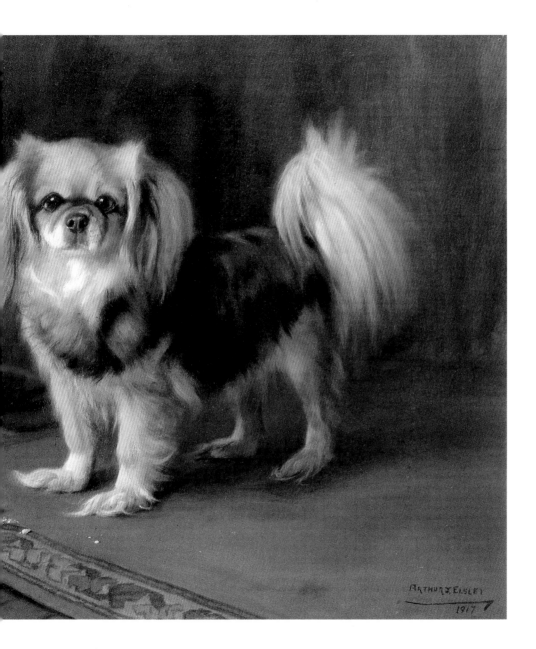

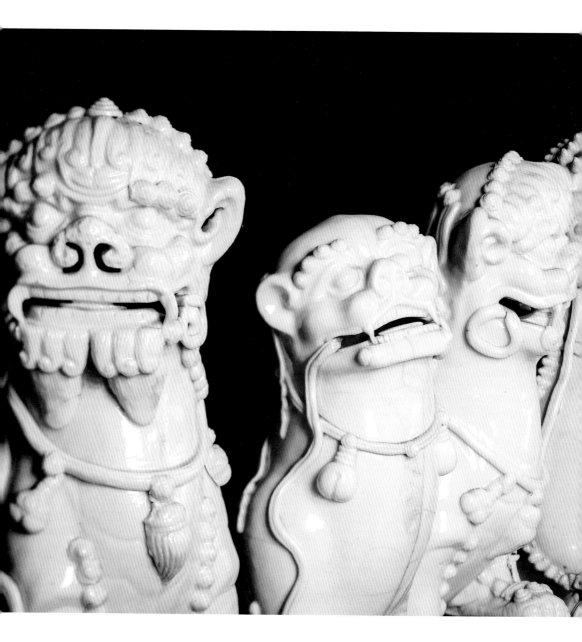

VARIOUS ANONYMOUS MAKERS

124 Blanc de Chine Buddhist lions, c.1662–1795

White-glazed porcelain, 11 to 51 cm height
Bequeathed as part of the Stanford Bequest of Preston Manor & Gardens and its contents to the
Brighton Corporation in 1932
PM325331–PM325416

THE COLLECTION OF WHITE-GLAZED porcelain Chinese Buddhist lions, often wrongly referred to as Dogs of Fo ('Fo' meaning 'Buddha'), was assembled by the wealthy upper-class owner of Preston Manor & Gardens, Ellen Thomas-Stanford (1848–1932), early in the twentieth century. She acquired the lions at auction or from dealers in London and Brighton with apparent unconcern for condition, as some show kiln-firing faults. These small porcelain lions are descended from the larger bronze lions that were placed at either side of Buddhist temple entrances in China from around 1000 CE. They sit in obedience as reminders of the need to subdue the passions. In the sixteenth-century miniature versions were occasionally used decoratively but most were made for western buyers. The pair usually consists of a male with his paw on a ball, and the female with a cub, although the majority exhibited at Preston Manor are males with joss stick holders. Those with fine applied decoration of prunus and other flowers are particularly rare.

Ellen Thomas-Stanford's indiscriminate acquisition of the lions indicates a collection driven by a fixated love of possession, the thrill of seeing the same talisman object in repeat, rather than a collection made for investment or scholarly purposes.

The 124 lions were placed in a large eighteenth-century mahogany break-front bookcase in the dining room in Preston Manor and would have provided a talking point for guests at dinner parties hosted by the Stanfords. When the bookcase was full the collection was deemed complete! Ellen's only curatorial action was her habit of keeping dealers' receipts rolled in the hollow bases. These documents show some were incorrectly identified and priced as Ming dynasty when they date from the later Kangxi, Yongzheng and Qianlong dynastic periods. If the dealers' deceptive appraisals were intended to lure the amateur collector, the ruse was a success.

Edwardian Queen Ann Revival walled garden at
Preston Manor, c.1905, restored 2000

ONE OF THE MOST LOVED PARTS OF Preston Manor is its walled garden.
Schematically late Victorian and Edwardian, the garden is described
in an 1895 edition of *Gardener's Chronicle* as having 'mingled fruits
and hardy flowers, after the manner of gardens in olden times …
there is a charm about these old-fashioned gardens which is lacking
in modern, and what are called well-kept gardens.'

The garden is bounded by high
flint and brick walls within which a
restrained formality is created by space
divided into four square plots, each
separated by interconnecting flagstone
paths. Inside each plot the abundant
planting schemes and multi-hued
herbaceous borders are inspired by the
poetic and artistic. This unconstrained
approach with its luxuriant visual effect
is sometimes known as 'Queen Ann' or
Romantic Garden Revival and echoes
the pleasing variability, elaborate motifs

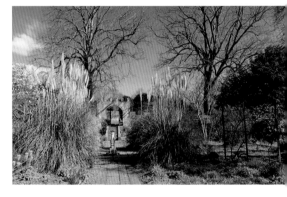

and ornamentation of Queen Ann revival architecture of the late
nineteenth and early twentieth centuries. Earlier schemes on the
site prefigure later aspirations: a plan of 1617 shows a simple square-
framed knot garden incorporating plots in the shape of a Maltese cross.

This is a garden designed for opulent Edwardian tastes with tall
feathery ornamental grasses, bowers of heavily scented roses and
lilacs under mature trees including a fruiting mulberry. A modest pet
cemetery of the period, with a row of 16 miniature tombstones senti-
mentally inscribed and set in an outdoor fernery, is a particularly
interesting and evocative feature.

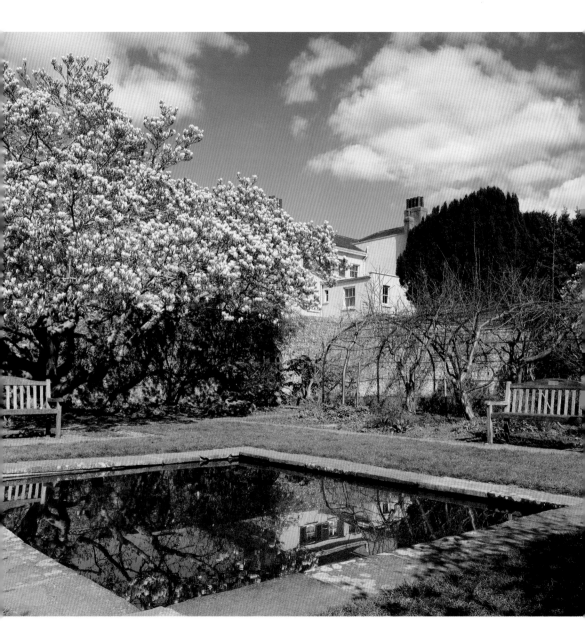

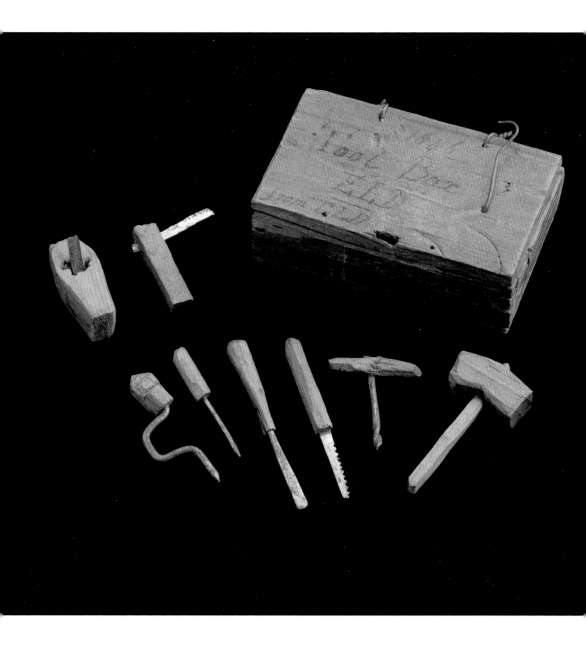

CHARLES LUTWIDGE DODGSON, 1832–1898

The Lewis Carroll toolbox, 1846

Wood and metal, 2 × 5 × 3 cm

Donated by Frances Menella Dodgson to the National Toy Museum in 1959, which became part of Brighton
Museum & Art Gallery collections in 1970

RO/1/73

BRIGHTON & HOVE MUSEUMS' collections include historic toys. One of the strangest is the miniature wooden toolbox containing eight tiny hand tools made by schoolboy Lewis Carroll – later, author of *Alice in Wonderland* (1865) – as a present for his favourite sister.

Charles Lutwidge Dodgson first used the pen name of 'Lewis Carroll' in 1856. He was born to High Anglican parents, his father being Vicar of Daresbury in Cheshire. Charles was the eldest son, third of 11 children and his favourite sister, Elizabeth Lucy Dodgson, was two years older. From 1846 to 1849, he was a boarder to Rugby School, and it was during that first year that he made this miniature toolbox, inscribing the lid in ink with '1846 ELD from CLD'. The box contained tiny handmade woodworking tools, including a plane, a drill and a saw, made from metal and wood. It must have been a treasured gift; despite its match-box size the whole set survives. These tiny woodworking tools are also reminders of Lewis Carroll's comical poem 'The Walrus and the Carpenter' – was he already beginning to create imaginary worlds?

Frances Menella Dodgson (1877–1963), Charles Dodgson's niece, was the last Dodgson to own the toolbox. In 1959 she gave the toolbox to the National Toy Museum, then based at Rottingdean Grange. In her letters she wrote 'We were anxious that it should find a home where it would be safe … I hope it may prove of interest to those who see it – I think you were told that it was made by Lewis Carroll'.

The National Toy Museum became part of Brighton Museum collections in 1970. In 1973 the toolbox was loaned to Longleat, home of the Marquess of Bath, for an 'Alice' exhibition where it was displayed alongside other objects in a case of 'important family possessions', loaned by several Dodgson relatives. That this treasured family possession is in public ownership is a privilege indeed.

Experimental 42mm-gauge cine camera, c.1896

Wood, brass and leather
Part of the Barnes Collection purchased by Friends of Hove Museum & Art Gallery from John Barnes (funded by The Headley Trust) in 1997
MF000073

Edward Carr, Press Photo Co., (Brighton)

'Opening of the Duke of York's Cinema, Preston Circus, Sept. 22, 1910'

Photographic postcard, 8.7 × 13.7 mm
Part of the Barnes Collection purchased by Friends of Hove Museum & Art Gallery from John Barnes (funded by The Headley Trust) in 1997
MF000134

From 1939, brothers John and William Barnes built a large private collection dedicated to the origins of cinema, such as optical toys and the magic lantern, through to early filmmaking in Britain. This formed the basis for their own Museum of Cinematography in St Ives, Cornwall (1963–86).

In 1997 Hove Museum of Creativity acquired part of the Barnes Collection relating to early filmmaking in the southeast of England. Consisting of over 500 objects, it documents the rise of this medium through original cameras and projectors, photographs, postcards, theatre programmes, publications and lantern slides. Many of the objects are associated with the Brighton School – the early British film pioneers George Albert Smith (1864–1959) and James Williamson (1855–1933), and their unique place in the birth of cinema.

One of the collection's highlights is this innovative camera made by Alfred Darling (1862–1931), a engineer based in Brighton. Working closely with local filmmakers, he experimented with the capabilities and capacity of cameras, adapting existing stock. This example was made as an experiment in film gauge size. It was designed for a wide 42mm-gauge filmstrip, before 35mm film became the industry standard.

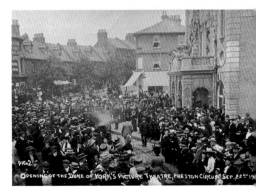

This postcard – another rare find – marks the opening of the Duke of York's Cinema. Still operating today, the building is Brighton's first purpose built cinema and is one of the UK's oldest single-screen cinemas.

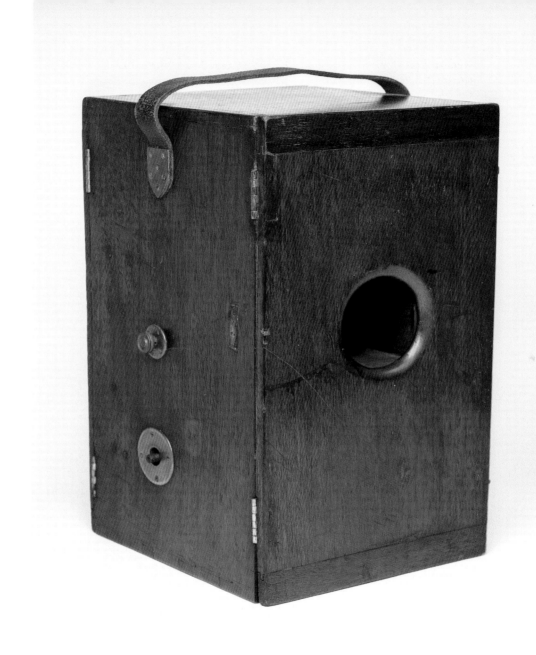

First published in 2022 by
Scala Arts & Heritage Publishers Ltd
305 Access House, 141–157 Acre Lane
London SW2 5UA
www.scalapublishers.com

In association with © Brighton & Hove Museums 2022

I am incredibly grateful to my colleagues at Brighton & Hove Museums for their work on this book: objects selections and text writing has been very much a team effort and has drawn on their many years of expertise and dedication to our amazing buildings, gardens and collections and making this accessible to as many people as possible.

Nicki Carter, Retail and Visitor Services Manager, helped with initial planning; Chloe Tapping, Director of Collections and Conservation, worked with me on selection and editing; and Nicola Coleby, Partnerships & Development Manager, edited the final text. Individual selections and text were provided by Kevin Bacon, David Beevers, Nicola Coleby, Stig Evans, Lucy Faithful, Helen Grundy, Rachel Heminway Hurst, Lee Ismail, Amy Junker Heslip, Cecilia Kendall, Alexia Lazou, Alexandra Loske, Martin Pel, Dan Robertson, Andy Thackray, Joy Whittam and Paula Wrightson.

ISBN: 978 1 78551 419 7
Edited by Claire Young
Designed by Linda Lundin, Park Studio
Printed in China

FRONT COVER:
Details of the Royal Pavilion, East front. Photographer: Simon Dack

BACK COVER:
Details of the Royal Pavillion, East front. Photographer: JJ Waller

FRONT INSIDE COVER:
The Booth Museum of Natural History. Photographer: Jim Holden

BACK INSIDE COVER:
Hedley Swain. Photographer: Simon Dack.

FRONTISPIECE:
Spencer Gore, *The West Pier, Brighton*, 1913